EDWARD
LEAR'S
BIRDS

EDWARD LEAR'S BIRDS

Susan Hyman

Introduction by Philip Hofer

WILLIAM MORROW AND COMPANY, INC.
NEW YORK 1980

FOR MY FATHER

First published in Great Britain by
George Weidenfeld & Nicolson Limited
91 Clapham High Street London sw4
Designed by Allison Waterhouse

Library of Congress Catalog Card Number 80–80860
ISBN 0–688–03671–6

Filmset by Keyspools Limited, Golborne, Lancs
Colour separations by Newsele Litho Limited
Printed and bound in Italy by L.E.G.O., Vicenza

CONTENTS

AUTHOR'S ACKNOWLEDGMENTS

Vivien Noakes' biography, *Edward Lear: The Life of a Wanderer*, provided much of the information in my discussion of Lear's early life. Vivien Noakes herself provided advice, information and illustrations; her help over the past few years has been invaluable. Among other sources, I would also like to cite Colin Bailey's introduction to the Walker Art Gallery's catalogue, *Edward Lear and Knowsley*, Brian Reade's book, *Edward Lear's Parrots*, and his preface to the catalogue of the Arts Council exhibition of 1958, still the best and kindest introduction to the intricacies of Lear's eclectic *oeuvre*.

For permission to quote from unpublished sources I am grateful to the Earl of Derby, Lord Tennyson and the Houghton Library, Harvard University. The reproduction of watercolours in the Knowsley Library was made possible by gracious permission of the Earl of Derby and with the help of his secretary Denis Lyonson and the librarian, Diana Kay. At the Houghton Library Eleanor Garvey and her staff have offered me every possible assistance; on a recent visit Susan Jackson took the time to trace many of the illustrations in this book. Eleanor MacLean of the Blacker-Wood Library of Zoology and Ornithology, McGill University, showed me the Lear collection and later identified many of the birds in the drawings. N.H. D'Oyly, Colonel William Prescott, Donald Gallup and Justin G. Schiller have generously loaned material from their personal collections.

I am also grateful for help received at: the British Museum (Natural History); Linnean Society; Zoological Society of London; Somerset Record Office, Taunton; Tennyson Research Centre, Lincoln; National Library of Scotland; Department of Prints and Drawings, British Museum; Department of Prints and Drawings, Victoria and Albert Museum; Tate Gallery; Fitzwilliam Museum; Sotheby Parke Bernet; Thomas Agnew and Sons; Christie's; Spink and Son; Maas Gallery; the Leger Galleries; Hazlitt, Gooden & Fox; Fine Art Society; Bernard Quaritch; Pierpont Morgan Library; Yale Center for British Art; Beinecke Library, Yale University; Henry E. Huntington Library and Art Gallery.

Among many friends who helped, I would particularly like to thank Russell Ash, who suggested the idea for the book; Joel Bender, who typed the manuscript; Roger Pasquier, for corrections to my ornithology; Ned Cox, Bernice Thomas, John Raish and John Glaves-Smith for assistance with picture research; Patrick Bade for German translations; Penny Dean, Attila the Hen and David Hudson. I would also like to thank Francis Walton for sending material from the Gennadius Library in Athens, Ray Gardner and Angelo Hornak for photography, Charles Lewsen and Peter Morgan.

At Weidenfeld and Nicolson, I cannot recommend too highly Beatrice Phillpotts' Fleet Street Delivery Service, and am grateful to Allison Waterhouse for her sympathetic designs, Mark Boxer for his interest in the book and Brigid Avison for her good judgment and good humour in editing it. At every stage of the book, Philip Hofer's continued kindness has been the happiest encouragement.

COLOUR PLATES

continued overleaf

8

INTRODUCTION

It is a pleasure to write an introduction to so well documented and original a study as *Edward Lear's Birds*. The subject matter has never before been thoroughly covered, and this book will undoubtedly be the standard work on Lear as an ornithologist for a long time.

Lear took up natural history in his earliest teens, was forced to abandon it around 1836–7, and continually harked back to it throughout his long life of over seventy-five years. His Nonsense books and alphabets, travel journals, landscape drawings, and ambitious yet relatively unsuccessful paintings were all subject to, and dependent on, friendships founded before he was twenty-five years old. His discipline and work habits were mainly formed then, before he began a more general artistic career and the life of an inveterate wanderer in southern climes.

Yet it is apparent that Lear did not regret his decision to abandon his early ornithological work. He felt it was absolutely necessary, although he could have made a far more secure livelihood than that which he attained in other fields. There were cogent reasons for the change, and for his departure from England when two-thirds of his life still lay ahead of him. His family's fortune almost vanished and he suffered severely in health, nerves and eyesight because of the precision required to draw, lithograph and colour his many natural history projects. In addition he was a victim of frequent epileptic attacks, chronic asthma and bronchitis, and – most important – a deep sense of inferiority due to his frequent illness, personal awkwardness, lack of social graces, and stringent need for money. He never married, although at intervals he gave agonized thought to the subject, and altogether his life was a series of 'ups and downs', depressions greatly predominating which he attempted to overcome by long hours of discipline and application. Yet despite his afflictions he developed an amazing gift for personal friendships with young and old; he wrote, literally, thousands of letters, and never allowed a friendship to lapse that could be preserved by small attentions.

Probably, had his health permitted, Lear would have gained a wider artistic reputation, since he is perhaps the greatest draughtsman of birds in European culture; Audubon is probably his only rival in all western civilization. Lear felt deeply the lack of recognition by his English contemporaries, of whom John Gould (who used Lear's work whilst giving him almost no credit, even erasing his name from some plates) is the outstanding – even wicked – example. Much of Lear's most important work remained unsold at his death on 29 January 1888, and it is only during the last twenty years that Lear the artist has been truly appreciated. When two huge collections appeared, suddenly, at a series of auctions in London in 1929, they overwhelmed a narrow market; the Franklin Lushington and Northbrook estates received a pittance for their holdings of drawings, books, Nonsenses and paintings. Now the prices of Lear's originals have mounted fantastically, and few collectors can afford them. But they should be grateful that careful scholars like Susan Hyman are giving a true evaluation of their significance.

Philip Hofer
Houghton Library, Harvard University
Cambridge, Massachusetts

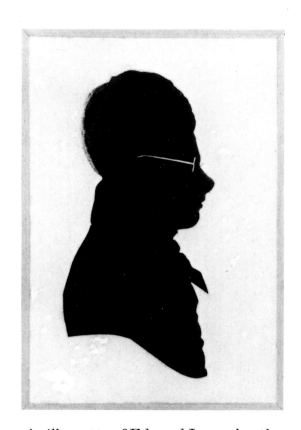

A silhouette of Edward Lear, shortly
after he began work as a zoological
draughtsman, by an unknown artist.

In the summer of 1880, during his last visit to London, Edward Lear dined with a young friend at the Zoological Gardens in Regent's Park. Hubert Congreve, then a student at London University, recalled that Lear said to him, 'You are just beginning the battle of life ... and we will spend the evening where I began it.' The two men, one dreaming of success, the other reliving it, talked into the night.

It was a beautiful evening in July and we dined in the open and sat under the trees till the gardens closed, he telling me all the story of his boyhood and early struggles, and of his meeting with Lord Derby in those gardens, and the outcome of that meeting – the now famous book, 'The Knowsley Menagerie'. I never spent a more enjoyable evening with him.

Lear's brilliant career as a natural historian was long forgotten. He was well known as a landscape painter and author of travel journals, and well loved as the creator of Nonsense poems and limericks. But in his youth he had worked in the Gardens as a zoological draughtsman, and in his twentieth year had published a fine folio volume on the family of parrots, much praised for its accuracy, originality and beauty. That success had led to another: for four years he had worked for the Earl of Derby, drawing the menagerie and aviary at Knowsley Hall; and in a short time he became an intimate of the Earl's family and friends.

In the decades after he had renounced his naturalist studies Lear seems never to have regretted his decision. Yet during his long wanderings and his struggles for acceptance as a painter, the Zoo haunted him as a place where he had once attained a kind of triumph. He revisited it often, writing, 'Those Gardens are such a Milestone and Landmark in my Life that I like to go there while in England.' The distinction of his early work, the praise and recognition that initially attended it, were a continuing comfort.

Edward Lear was born in 1812 in Highgate, then a rural village above London. He destroyed the diaries for the first half of his life and seldom mentioned his childhood; the accounts he left in memoirs and letters show a turn for melodrama and comic creation. The incidents he described in his family history are almost entirely imaginary. According to Lear, his family was of Danish extraction, his grandfather having changed the spelling of the name LØR to suit English pronunciation: '[He] picked off the two dots and pulled out the diagonal line and made the word Lear'. Lear's father, Jeremiah, was a prosperous London stockbroker, maintaining a fine house, Bowman's Lodge, twelve carriages and a retinue of

servants for his wife and expansive family; Edward was the twentieth of twenty-one children. Then on a black day in 1816 Mr Lear went bankrupt. The house and carriages had to be sold, the servants dispersed. Mrs Lear installed her family in squalid lodgings in 'horrid New Street' within reach of King's Bench Prison, devoting her energies to clearing her husband's debts and visiting him every day with 'a full six-course dinner with the delicacies of the season'. The children fared less well. Two sons emigrated to America and a third went as a medical missionary to West Africa. The daughters were sent out to make their living as governesses and companions and within four months four of them expired, unable to bear the hardships of their new life.

Until recently Lear's astonishing story was accepted quite literally; now it seems rather to share the sense of his Nonsense, for Lear never told the truth more eloquently than when he was inventing it. He chronicled his melancholy tale in an *Eclogue*:

> *In dreary silence down the bustling road*
> *The Lears with all their goods and chattels rode . . .*

Much of it is fanciful: there is no confirmation of Danish descent, bankruptcy, prison or the four fragile daughters. But the truth was equally traumatic. The outline of disaster and desertion was accurate; Lear's childhood was lonely and frightening. A sickly, high-strung boy, he was awkward, short-sighted, and susceptible to frequent attacks of asthma and bronchitis. From the age of seven he suffered from what he later referred to as 'The Terrible Demon' and 'The Morbids', epileptic seizures followed by bouts of debilitating depression. In a period of financial distress, the family divided, though still living together at Bowman's Lodge. Lear's mother, who seems to have grown indifferent to the joys of maternity after the birth of her twenty-first child, abandoned him to the care of his sister Ann, twenty-two years his senior. Eventually, on the strength of a modest annuity from her grandmother, Ann moved with her brother into rooms in Upper North Street, off Gray's Inn Road.

Once again I was roaming
 through fields and flowers
& I felt at each step new joys
The first half of an illustrated quatrain in which Lear recalls his childhood discovery of the countryside.

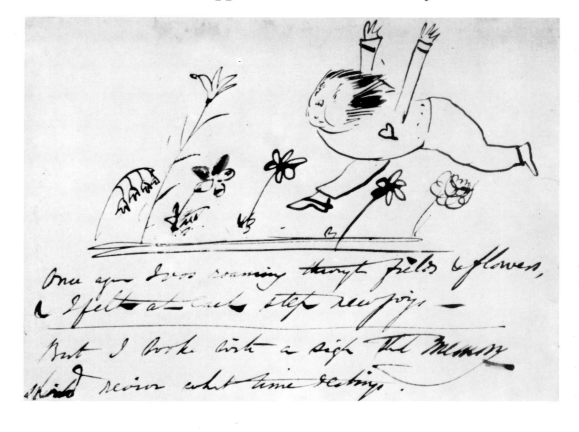

Edward Lear, painter, poet, naturalist, traveller, musician and linguist, learned to teach himself at an early age. Except for a year of school when he was eleven, and lessons from his sisters Ann and Sarah, he was entirely self-educated. From his childhood he had a consuming interest in literature, art and animals. Ann introduced him to the Bible, classical mythology and the Romantic poets, and encouraged him to write poetry himself. Both sisters were talented artists and under their instruction he learned to observe and to record in methodical detail flowers, butterflies and birds. He pored over books of natural history and painstakingly copied all the plates of animals in the Comte de Buffon's forty-four part encyclopedia of the biological kingdom. His father had a good collection of pictures, and Lear later described the Painting Room opposite the nursery as 'the happiest of all my life'.

After 1823 he often visited his sister Sarah who had married and lived in Arundel, Sussex. In his rambles through the countryside he persevered with his studies; clearly his precocious artistic talents were inseparable from a delighted curiosity in nature. His childhood works record his botanical and zoological discoveries; there are scarcely any figures or scenes from the imagination, but several drawings of birds reveal the humorous appreciation of animal personality which was to distinguish his later art. A collection of drawings and watercolours belonging to the National Gallery of Scotland includes pictures of birds and landscapes in the decorous album style of the 1820s; his sisters had passed on to him their own fashionable attainments. Another early sketchbook, now in the Houghton Library at Harvard, contains paintings of birds, insects, shells, flowers, fish, feathers and landscapes, some cut out and pasted on to the page. They are all meticulously precise, and across a drawing of a nettle Lear has written the Latin names of its class, order and species. At least one of the bird drawings is by Ann, a graceful vignette similar in style to Lear's album sketches.

Before the days of public museums, most works by important artists were housed in private galleries. In 1826 Lear met Lord de

Lear admired the Romantic poets and shared their interest in Hellenism. He wrote odes in praise of antiquity and several of his early drawings include classical ruins. The owl of Minerva is from one of his sketch books.

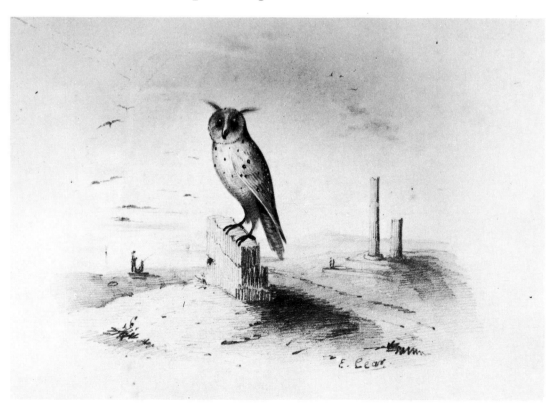

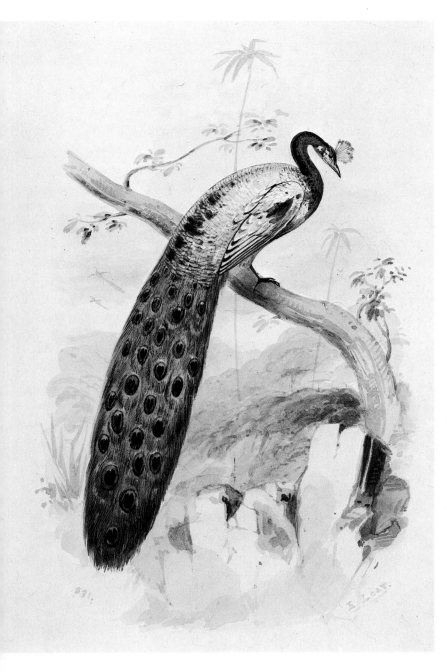

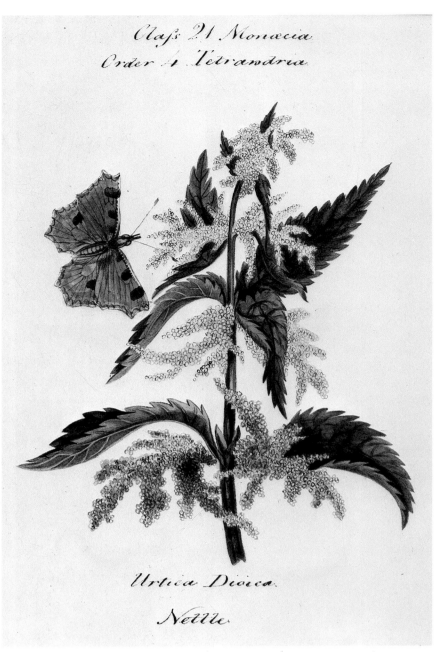

Above Javanese Peacock, 1831. This delicate watercolour with its exotic setting shows the persisting influence of Ann Lear's tuition.

Right Lear has elegantly inscribed this watercolour of a nettle, which he then cut and pasted into an album of nature studies, with its Latin nomenclature.

Tabley, the founder of the British Institution for the Encouragement of British Art who had opened his collection in London to the public. Lear's visits to Arundel gave him another introduction to the English art world. At nearby Petworth, seat of the Earl of Egremont, he studied the works of Turner and cultivated a taste for landscape in the grand manner. Lord Egremont was one of the most important patrons of the early nineteenth century; his hospitality to Turner at Petworth was not unlike that later enjoyed by Lear at Knowsley Hall, home of the Earl of Derby. At Arundel Lear was also introduced to Walter Ramsden Fawkes, another Turner collector, and to his daughter, Mrs Godfrey Wentworth. Her father had been an amateur zoologist and friend of Prideaux John Selby, the natural historian and ornithologist. It was probably through Mrs Wentworth that Lear gained employment at the Zoological Society and began working for Selby. An album of zoological drawings dated 1830 is dedicated to her family 'in acknowledgement of their kindness towards him'. These early acquaintances were important in another sense as well, for they belonged to that class of society upon which Lear depended for patronage throughout his life. Lord Egremont was one of the subscribers to Lear's *Parrots*, along with Mrs Wentworth and no fewer than seven members of her family.

Had there been money, Lear would certainly have gone to art school; all his life he bitterly regretted his lack of formal training. As it was, he began to earn his living at the age of fifteen, giving private drawing lessons to young ladies of good family, perhaps through the influence of his Sussex friends. Some of his other work was less congenial. 'For bread and cheese' he turned out 'uncommon queer shop-sketches – selling them for prices varying from ninepence to four shillings: colouring prints, screens, fans; awhile making morbid disease drawings for hospitals and certain doctors of physic.' Most of this was hack-work, but the colouring of prints would have been a useful experience for an artist who later supervised the colouring of his own lithographs.

Some time around 1828 Lear began working professionally as a zoological draughtsman. The first volume of Prideaux Selby and Sir William Jardine's *Illustrations of British Ornithology* appeared in 1825 and Lear contributed plates for two of the later volumes. He was also sketching in the newly opened Zoological Gardens; several of the pages in the Harvard sketchbook are labelled 'Zoo'. A watercolour of a small rodent (*Hyrax Capensis*) is Lear's first datable animal drawing; on the page he has written 'Sketched at 17. Drew Broad St. April 13th 1832'. The gap in dates is interesting, for it reveals something of Lear's methods. He first made a sketch with pencilled colour notes and later, sometimes after a long interval, 'drew' or completed it with watercolour washes, tracing his pencilled notes in ink. As a landscape artist he worked in much the same way, making rapid sketches and notes on the spot, and 'penning out' the sketches in his studio. He followed this formula for over sixty years.

In 1829 Lear contributed drawings for wood-engravings illustrating a visitor's guidebook to the Zoo entitled *The Gardens and Menagerie of the Zoological Society Delineated*; edited by Edward Bennett, Secretary of the Society, the first volume, on quadrupeds, appeared in 1830, and the next, on birds, in 1831. The title page specifies 'Drawings by William Harvey; Engraved by Bryanston and Wright, assisted by other artists'. Despite the

Hyrax Capensis, 'Sketched at 17'.

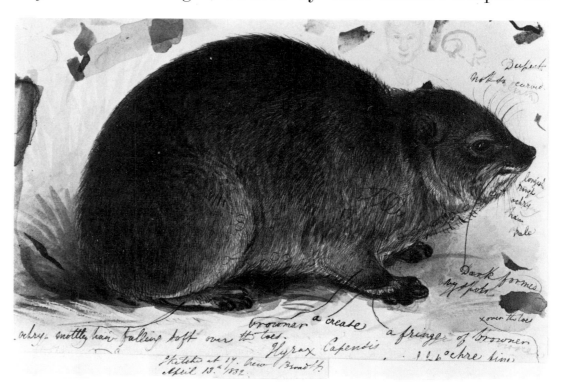

15

punctuation, the 'other artists', or at least Lear, appear to have assisted with the drawings rather than the engraving, for the letters 'EL' show clearly in a study of macaws, and two other vignettes of lemurs carry likely variations of his monogram. Several of the other drawings look like Lear's work, but in no others have the engravers retained his initials.

Lear never mentioned William Harvey, but it is worth noting that they worked together, for Harvey, a student of Thomas Bewick, the naturalist and reviver of wood-engraving, was unusual in his enthusiasm for the study of living animals at a time when most artists preferred to draw from stuffed specimens in the comfort of their studios. Harvey was also an innovator in his departure from the standard, formal side-view depiction of animals, a precedent important for Lear, who even in his early vignette of macaws shows one of the birds dangling upside down from a branch, while the other, seen from the back, peers over its shoulder. Lear captures their comic gymnastics, their mischievous energy and the intricate designs of their sweeping movements, so unlike the stiff, repetitious poses of many earlier bird books.

In 1831 Lear and his sister moved to 61 Albany Street on the east side of Regent's Park and within walking distance of the Zoological Gardens. In October he wrote to a friend, 'You will be pleased to know I am engaged in a Zoological Work shortly to appear from that Society.' A year before, Lear had applied to make drawings of parrots belonging to the Society. At the age of eighteen, with no financial backing and few connections, he embarked on a project that was to establish his reputation as a brilliant and original ornithological artist.

It was a vastly ambitious undertaking, but a shrewd one, for interest in natural science had never been greater. The early nineteenth century was an age of expansion and conquest, investigation and discovery. The advances in natural history classification made by Linnaeus and the founding of learned societies and journals had encouraged the study of ornithology as a serious science. The journeys of Captain Cook in the late eighteenth century had stimulated an interest in animal and plant life overseas and in the identification and description of new species. Although the illustrations made by the painters who accompanied Cook were never published, he began the tradition of sending scientists and trained artists on voyages of exploration, which led in the nineteenth century to the establishment of famous research ships such as the *Challenger*. Previously, ornithologists had written from memory or had based their accounts on the reports of earlier authors. Pictures based upon detailed observation were sometimes accompanied by an indiscriminate assortment of creatures derived from folklore, hearsay and Christian symbolism. Before 1800 there were still ornithologies which described the Barnacle Goose springing fully grown from shell-encrusted trees. The trend towards original observation and improvements in methods of preservation and the material collected on explorations led to more accurate descriptions of birds of different regions and families.

At the same time the public was eager to see what these newly discovered exotic creatures looked like, and clever entrepreneurs

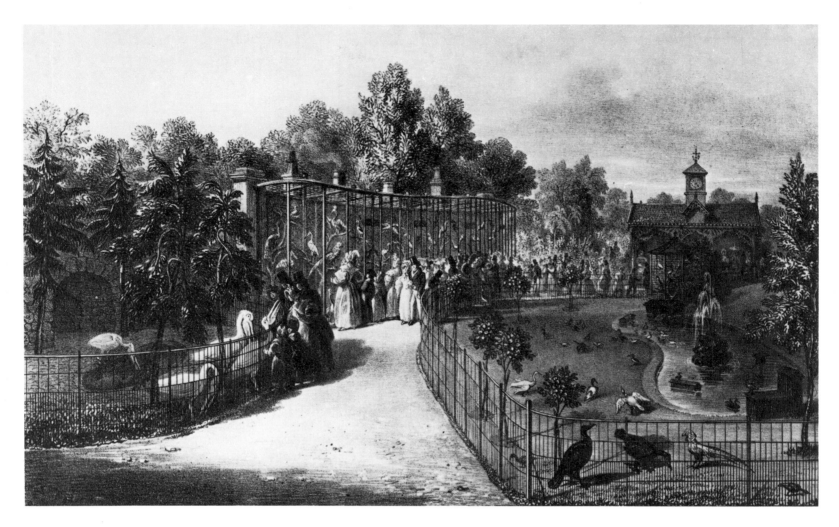

The Zoological Gardens, Regent's Park, in 1835, one of a series of lithographs by George Scharf printed by Charles Hullmandel.

were quick to take advantage of this enthusiasm. In London there was 'Polito's Wild Beasts' off the Strand at Exeter 'Change', as well as a fine collection of animals and birds, often used by artists, belonging to a Mr Herring in the Euston Road. The Surrey Zoo, opened in 1828, drew enthusiastic crowds. Apart from lions and tigers housed in an enormous glass conservatory, there were zebras, emus, kangaroos and a giant tortoise on which children could ride. In the same year the Zoological Gardens in London were opened by Humphrey Davy and Sir Stamford Raffles with exhibits that included specimens from the royal menagerie. Private menageries and museums were also popular; besides the grand collections of the Duke of Cumberland and the Earl of Derby, there was a vogue for rare animals among the lesser gentry. An occasional ostrich or strolling stork was considered very chic, a wandering wombat a stylish adornment to the grounds of any country house. Romantic zoology achieved its apotheosis in Dante Gabriel Rossetti's mad menagerie in London. In the desolate gardens behind his Chelsea house he assembled an enormous collection of curious but incompatible birds and animals; neighbours complained of screams in the night.

Prevailing interests also created a fashion for expensive bird books with hand-coloured engravings and aquatints sold by subscription to wealthy clients. These were often issued in monthly parts, with a contents list, introduction and index printed with the last instalment. After all the parts had been printed the plates and text were rearranged to group bird families together. When collated into massive volumes, finely printed on thick paper with stately frontispieces and rich binding, they were impressive works. Some were bought by zoologists of means, some by learned societies, but

most were purchased by affluent patrons of the arts. Ornithology was still something of an elegant recreation.

Lear's *Illustrations of the Family of Psittacidae, or Parrots*, which appeared in parts between 1830 and 1832, set new standards in ornithological publishing. Lear was the first to choose the large folio size which became general for later books; the proportions of the illustration to the 'natural size' of the bird were often inscribed in the plate. Audubon, the great American naturalist, went even further in his efforts to illustrate birds life-size with his rather daunting 'double-elephant' folio. Lear was also the first bird artist to work from living examples whenever possible and the first to produce his own lithographs. The devotion of an entire book to one family of birds was another innovation. The most distinguished and popular books, such as Bewick's *British Land Birds* of 1797 and his *Water Birds* of 1808, Selby and Jardine's *Illustrations of British Ornithology* and Audubon's monumental *Birds of America*, the first volume of which appeared in 1827, owed much of their attractiveness to being diverse and wide-ranging. Lear's decision was unusual, but it was also a reflection of contemporary taste. The brightly coloured plumage of the exotic parrot, its whimsical

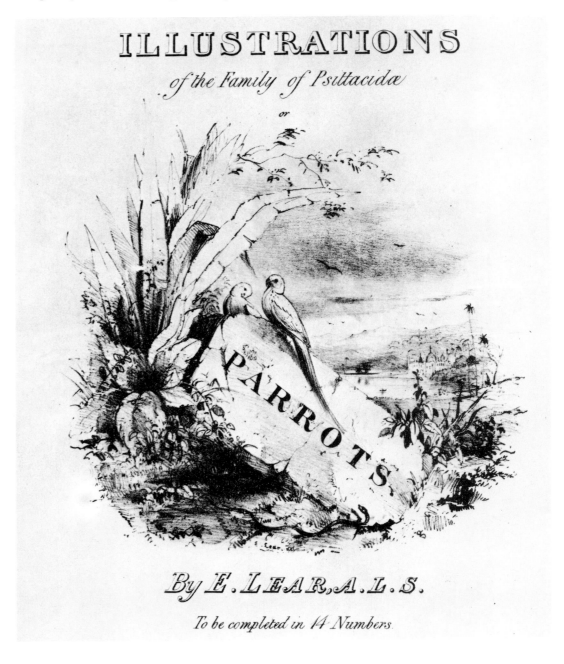

Detail of the wrapper of an early part of *Illustrations of the Family of Psittacidae, or Parrots*.
Although the legend reads 'To be completed in 14 Numbers', Lear never finished the series.

PALE-HEADED PARRAKEET (*Platycercus palliceps*)
Plate 19 *Illustrations of the Family of Psittacidae, or Parrots*

18

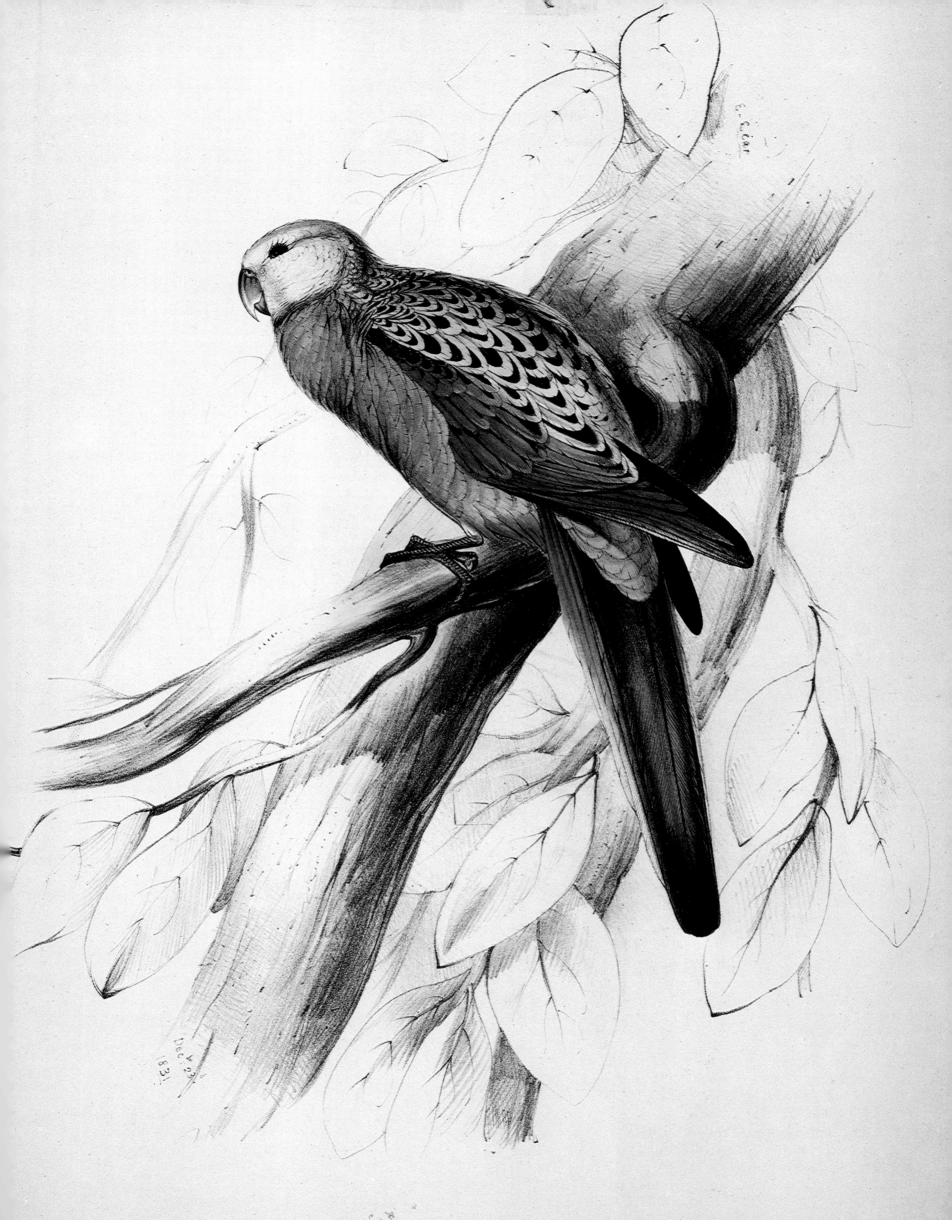

PLATYCERCUS PALLICEPS.

Paleheaded Parrakeet.

In the possesion of Mr. Leadbeater.

E. Lear del et lith. Printed by C. Hullmandel.

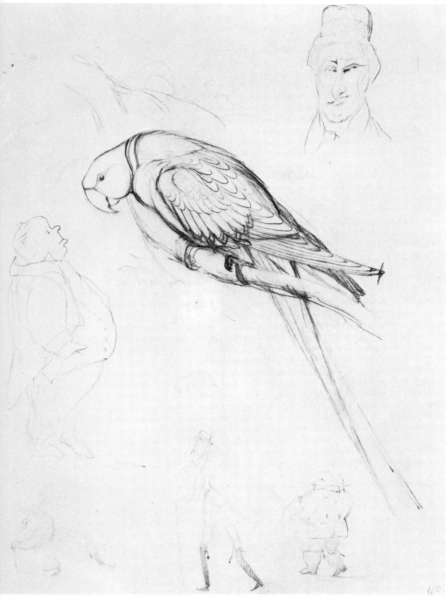

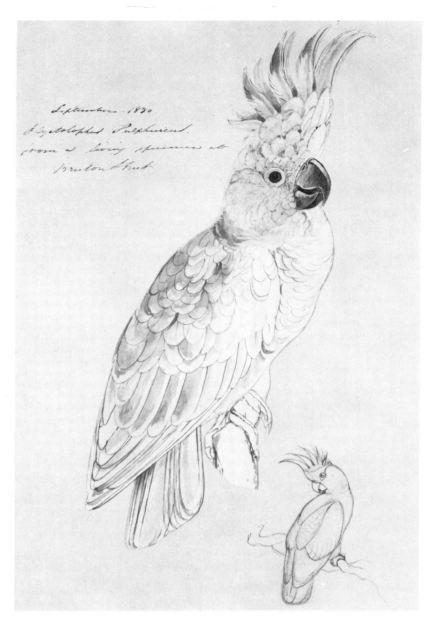

Above Lear began a drawing for the Rose-ringed Parrakeet but completed his page with disparaging sketches of those who gathered round him as he worked.

Right A study for the most personable of parrots, the Lesser Sulphur-crested Cockatoo, inscribed 'September 1830 Plyctolophus Sulphureus from a living specimen at Bruton Street'.

attitudes and its ability to mimic were widely prized. In the eighteenth century the parrot was often an accessory in aristocratic portraits. By the early nineteenth century it decorated Worcester and Meissen porcelain, while pet cockatoos and macaws were considered *de rigueur* for the rooms of literary salons. In Regent's Park the parrot house was one of the choice attractions.

Lear drew from live specimens whenever he could. Many of his predecessors had based their studies on stuffed birds or skins and, in Audubon's case, on birds that had been observed in their natural state but which were often killed before being drawn. Lear often worked in the parrot house in the Zoological Gardens. While a keeper named Gosse held the birds, Lear carefully measured their wing spans, the size of their beaks and the length of their legs. The massive biped in the elegant aviary soon became a popular exhibit himself. Trapped between squawking birds and gawking crowds, Lear, who had a low tolerance for noise, persevered with his pencil sketches and detailed colour notes. In some of these the encaged artist expressed his irritation by including unflattering portraits of the more intrusive members of his audience. At other times, he drew at the Society's headquarters at Bruton Street, where some of the birds were housed until new aviaries were ready.

KUHL'S PARRAKEET (*Psittacula kuhlii*)
Plate 38 *Illustrations of the Family of Psittacidae, or Parrots*

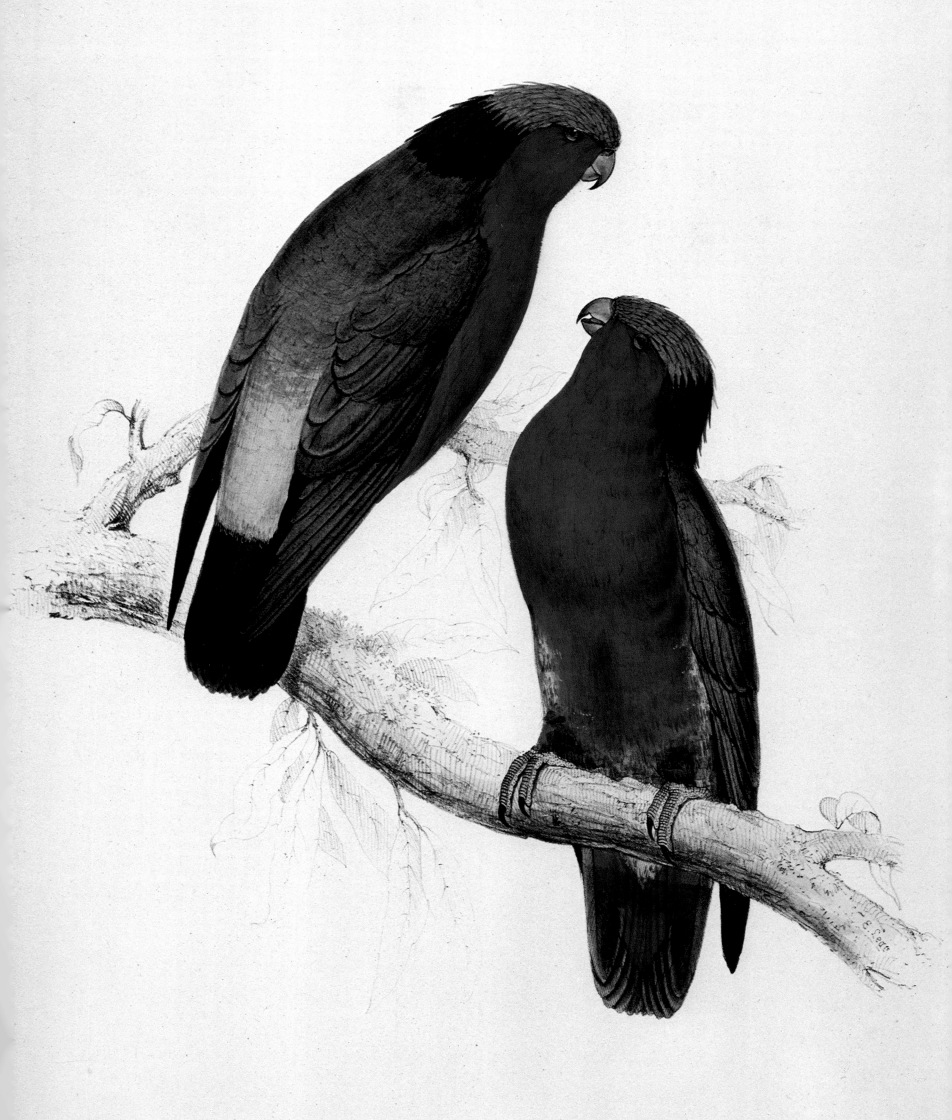

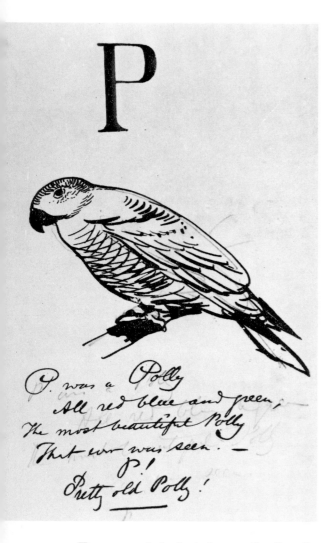

From an alphabet drawn for Lord Tennyson's sons, Hallam and Lionel, in 1859.

Having committed himself to representing all the parrots, Lear occasionally ran out of examples at the Zoo and had to look for specimens in private collections. He borrowed birds from Lord Stanley, then President of the Linnean Society, Mr Leadbeater, a dealer in natural history specimens, the naturalist Nicholas Vigors, and, when other sources failed, he drew from stuffed specimens lent by John Gould, the Society's taxidermist. But in his best plates he captured the waggish deportment of the living bird, sketching it from all directions and from all angles, swaying on its perch, balancing on a branch or crawling across the bars of its cage; a trial pull at Harvard not included in the published illustrations shows a bird hanging happily upside down.

Lear described the *Psittacidae* as 'the first complete volume of coloured drawings of birds on so large a scale published in England as far as I know – unless Audubon's pheasants were previously engraved'. Actually there were precedents for using lithographs – at least on a small scale – in the depiction of natural history, although in the 1820s most volumes, including those of Audubon, were still illustrated by hand-coloured prints from copper plates or wood-engravings. The first of the English natural histories to have lithographs was William Swainson's *Zoological Illustrations* of 1820–23, followed by Dr Thomas Horsfield's *Zoological Researches in Java and the Neighbouring Islands* published in 1824. C. W. Smith's small plates of Indian birds after drawings by Sir Charles d'Oyly were printed at Bihar in 1828 and Waterhouse Hawkins executed lithographs of bird and animal drawings by native artists for John Edward Gray's *Illustrations of Indian Zoology*, issued between 1830 and 1834.

The development of lithography in England was pioneered by two men who had visited its inventor, Alois Senefelder, in Munich. Rudolf Ackermann became a lithographic publisher, while Charles Hullmandel, a landscape painter, turned his attention to the practical issues of improving printing methods and teaching artists to draw on stone. The press he established in Great Marlborough Street in London became a virtual training school for both amateur and professional artists. Ackermann's translation of Senefelder's *Complete Course in Lithography*, published in 1819, was widely used as a handbook until it was superseded by Hullmandel's *The Art of Drawing on Stone* in 1824. In the preface to the 1835 edition of his treatise, Hullmandel described the advantages of the new process: 'Everyone making a drawing on stone originates a style of his own; and hence the infinite variety of manner in Lithography, which forms so peculiar a distinction between this art and engraving.'

Lear's claim to be the originator of lithographic bird books in England is not entirely accurate; his distinction is rather that he lithographed all of the plates for the *Psittacidae* himself. Lear probably went to Hullmandel for reasons of economic necessity; he had no money to employ an engraver and no apprenticeship in engraving, etching or any other reproductive medium. But lithography required no special training; the artist could draw

BAUDIN'S COCKATOO (*Calyptorhynchus baudinii*)
Plate 6 *Illustrations of the Family of Psittacidae, or Parrots*

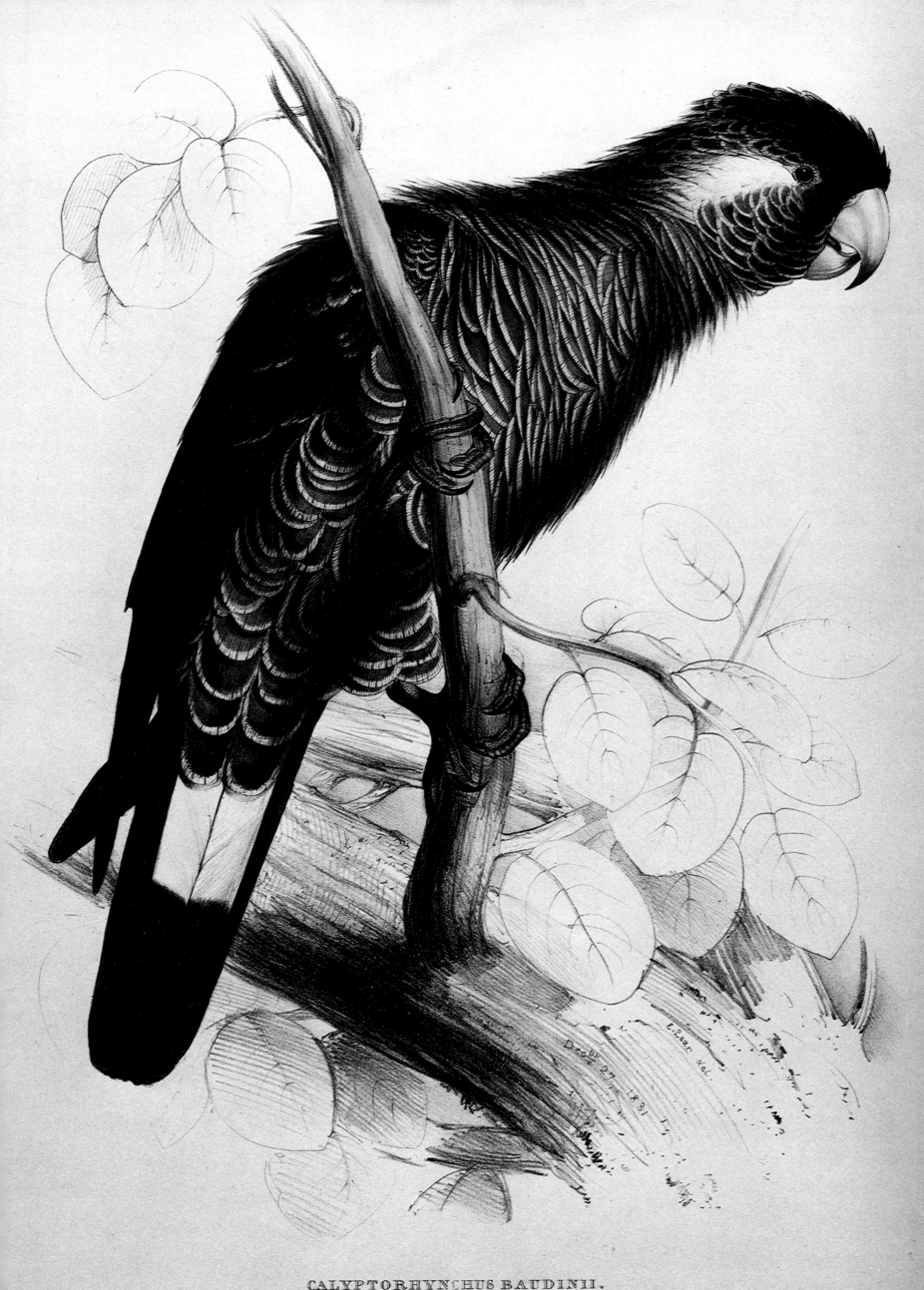

CALYPTORHYNCHUS BAUDINII.

Baudin's Cockatoo.

2/3 Nat.Size.

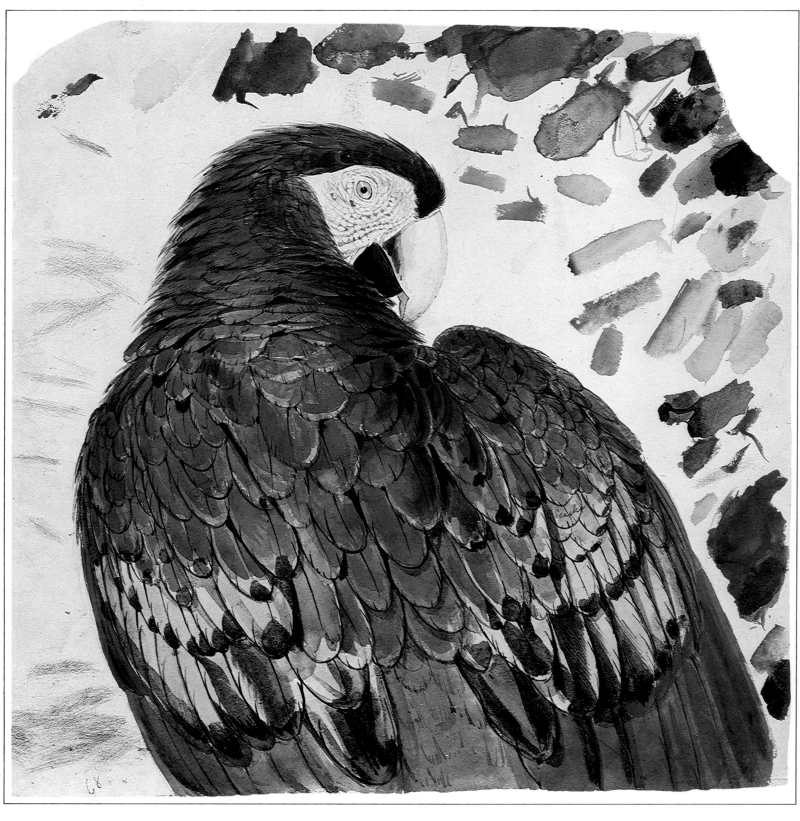

Two studies for the Red and Yellow Maccaw in the *Psittacidae*. Lear supervised the painting of the lithographic outline, and the notes and watercolour tests may have been used to direct his assistants. Few natural history artists have achieved such swift assurance of line and unstudied refinement of design and colour.

directly on the lithographic stone, from which faithful impressions of the drawings in reverse could be taken in hundreds. The style and spontaneity of the original work were preserved and its accuracy and integrity were not compromised by translation into the lines and dots of another medium. The artist could draw with a new freedom and could supervise the entire process in a way that would never have been possible with commercial engraving.

Several studies for the *Psittacidae*, now at Harvard, show the birds drawn in ink and watercolour over initial sketches in pencil. There are methodical notes and references as well as colour tests on each page. These preliminary studies would have been traced on the lithographic stone by Lear himself and trial impressions taken showing the bird reversed. Since alterations could not be made on the final plate, Lear often made trial runs of heads alone or of whole birds to see if corrections were necessary. The Department of Prints and Drawings at the Victoria and Albert Museum has several of

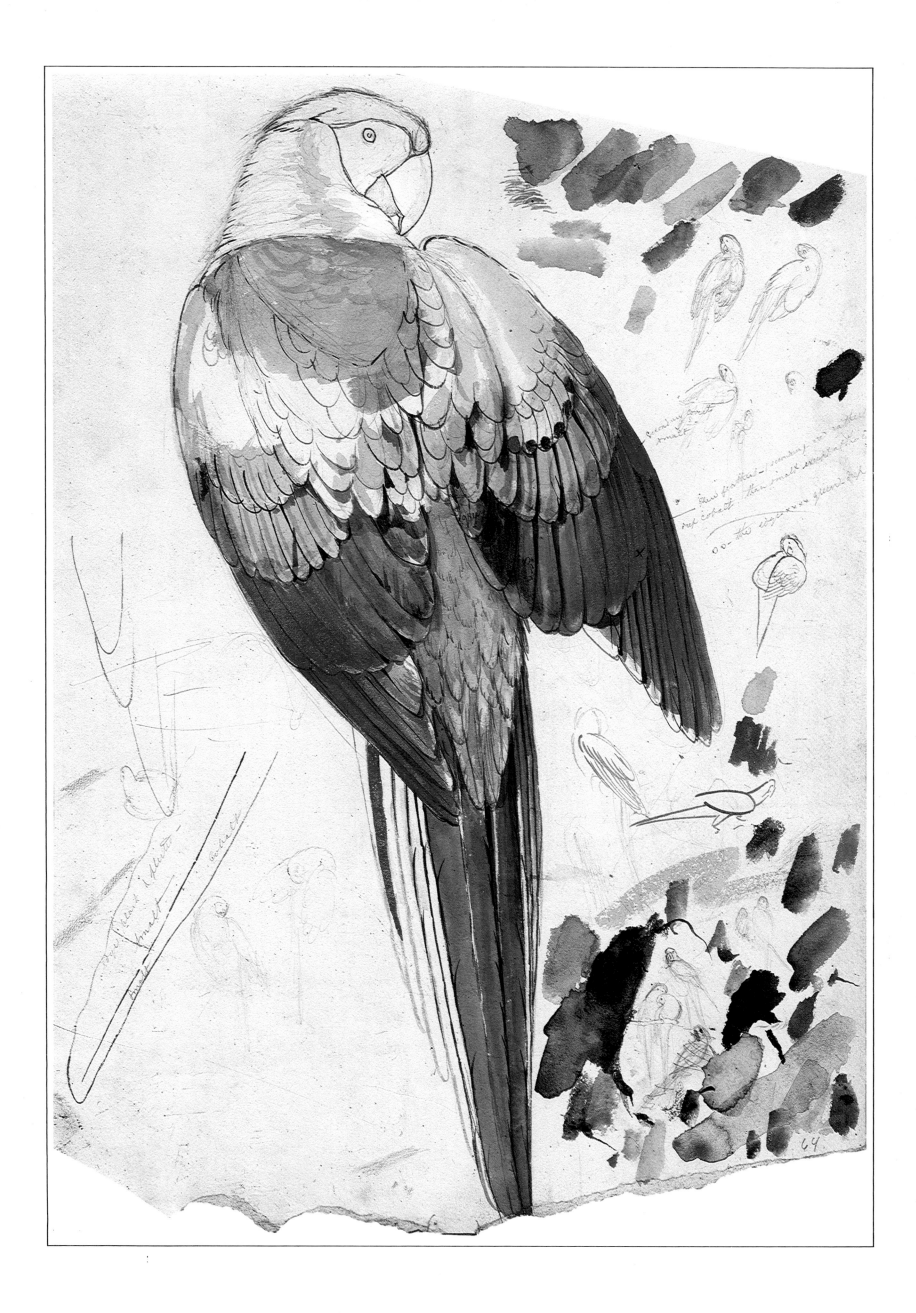

these experimental pulls, many of which must not have satisfied the artist, for they do not appear in the published parts. After the final prints were made, opaque watercolours were applied by hand by Hullmandel's assistants under Lear's supervision. A last application of white-of-egg to heighten the vivid flicker of a glance and the delicate iridescence of plumage gave the birds an uncanny physical presence.

Lear became one of the most accomplished craftsmen among the early lithographers. Certainly he was the first bird artist to appreciate the aesthetic possibilities in the grain of the lithographic stone, how it would be used to vary tone and sharpness of line, to render subtle textures and the gradation of closely-packed feathers. He worked with a rare dedication and stamina, totally absorbed in his project, his rooms crammed with notes, drawings and trial pulls. In 1831 he wrote in apology to a friend:

> I see no probability of your finding any rest consonant with the safety of my Parrots – seeing, that of the six chairs I possess 5 are at present occupied with lithographic prints:– the whole of my exalted & delightful upper tenement in fact overflows with them & for the last 12 months I have so moved thought looked at, existed among Parrots – that should any transmigration take place at my decease I am sure my soul would be very uncomfortable in anything but one of the Psittacidae.

The forty-two plates of the *Psittacidae* came out in twelve parts between November 1830 and April 1832. They were published by Lear himself with the assistance of Rudolf Ackermann. The final volume had no letterpress other than a dedication to Queen Adelaide and a list of subscribers which mentioned many eminent naturalists, including Nicholas Vigors, Prideaux Selby, Sir William Jardine, John Edward Gray, William Swainson and Lord Stanley. Despite the praise it received the book was not a financial success; of the 175 copies printed many were probably given away to friends. Lear abandoned his intention of figuring the entire parrot family. The projected last two parts were never issued. Lear wrote

Cockatooca Superba, an illustration of a new species found by Professor Bosh in the Valley of Verrikwier, near the Lake of Oddgrow and on the summit of the Hill Orfeltugg.

Above, left and right From a letter to a friend dated October 1831. Next to the self-portrait Lear wrote 'N.B. this is amazingly like'.

RED AND YELLOW MACCAW (*Macrocercus aracanga*)
Plate 7 *Illustrations of the Family of Psittacidae, or Parrots*

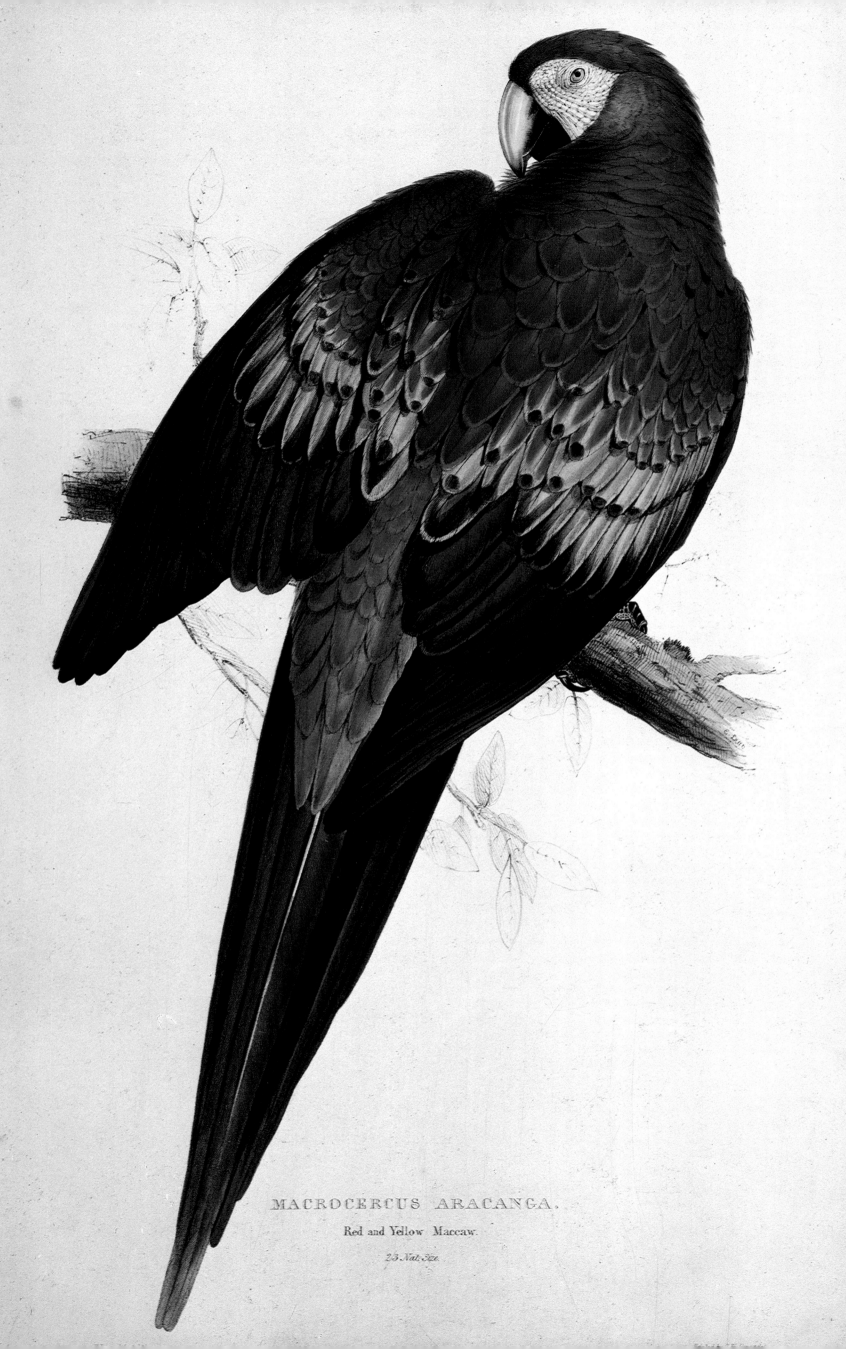

MACROCERCUS ARACANGA.

Red and Yellow Maccaw.

2/3 Nat. Size.

to Sir William Jardine: 'I stopped in time.... The publication was a speculation which so far as it made me known procured me employment, but in the matter of money occasionally caused loss.' In a letter of 1831 Lear despairs over his inability to meet the bills of his colourer and printer and complains that 'the tardy paying of many of my subscribers – renders it but too difficult to procure food'. He often considered abandoning the project altogether.

Lear's despondency about his financial failure must have been balanced by his certainty that artistically his work was a triumph, an extraordinary achievement for a youth of twenty. His best plates, those of the large flamboyant parrots, reveal a rare sensibility, one that could combine the most exacting scientific naturalism with a masterly sense of design and an intuitive sympathy for animal intelligence. Minutely exact in every detail of anatomy, plumage and colouring, the birds are portrayed against minimal backgrounds of lightly sketched branches, leaves and twigs. They lack Audubon's theatricality and atmosphere. But they endure as portraits of individuals rather than of species; vain, canny, eccentric, the Salmon-crested Cockatoo and the Blue and Yellow Maccaw exist as personalities in their own right.

Right, opposite and overleaf left Three preliminary studies in the development of the lithograph of the Salmon-crested Cockatoo (*Plyctolophus rosaceus*), plate 2 in the *Psittacidae* (*overleaf right*). An initial pen drawing is followed by a study with notes and colour tests and a finished watercolour. Lear copied the outline of the completed painting on to the lithographic stone; impressions taken in reverse were then coloured by assistants to produce the published plate.

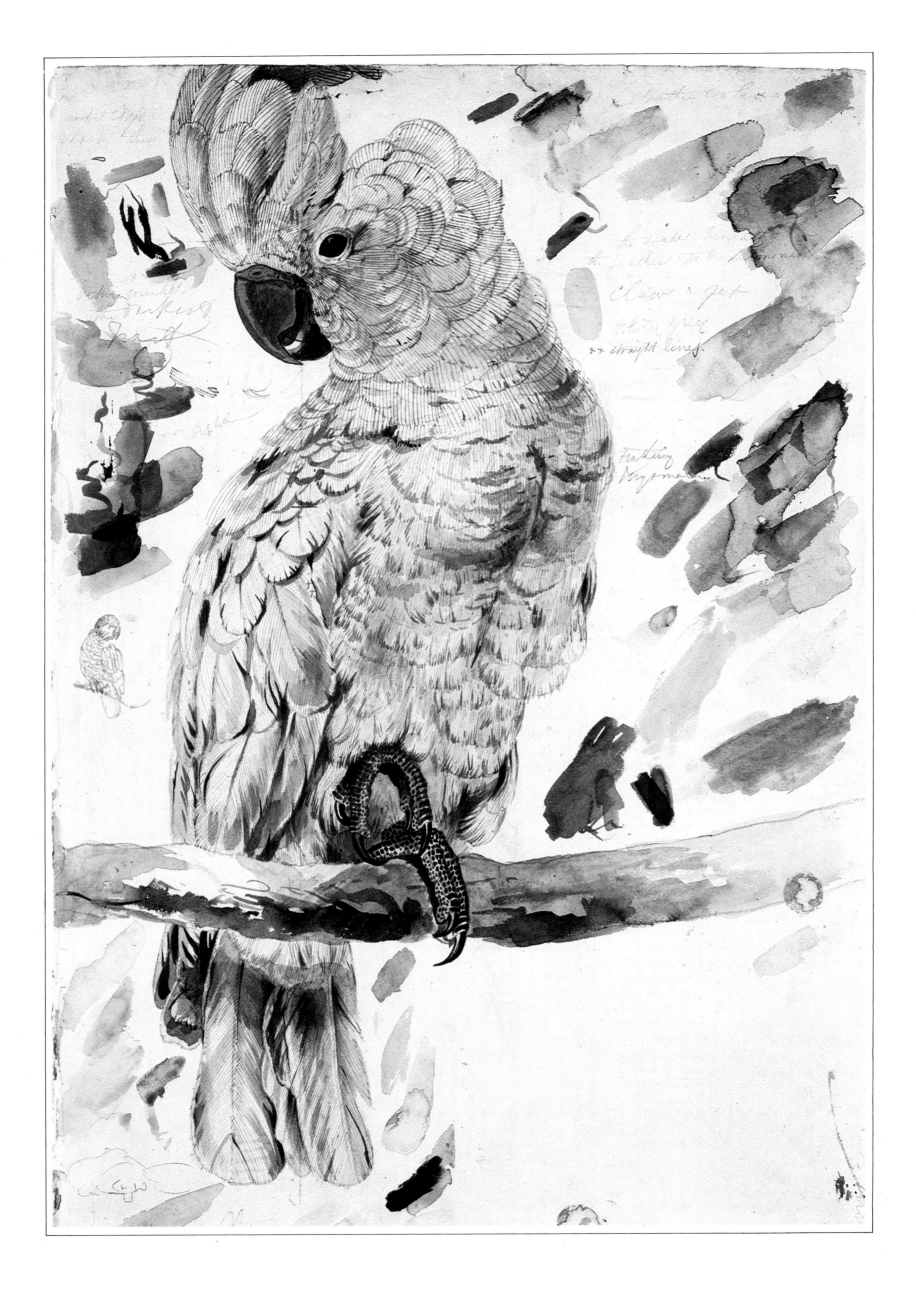

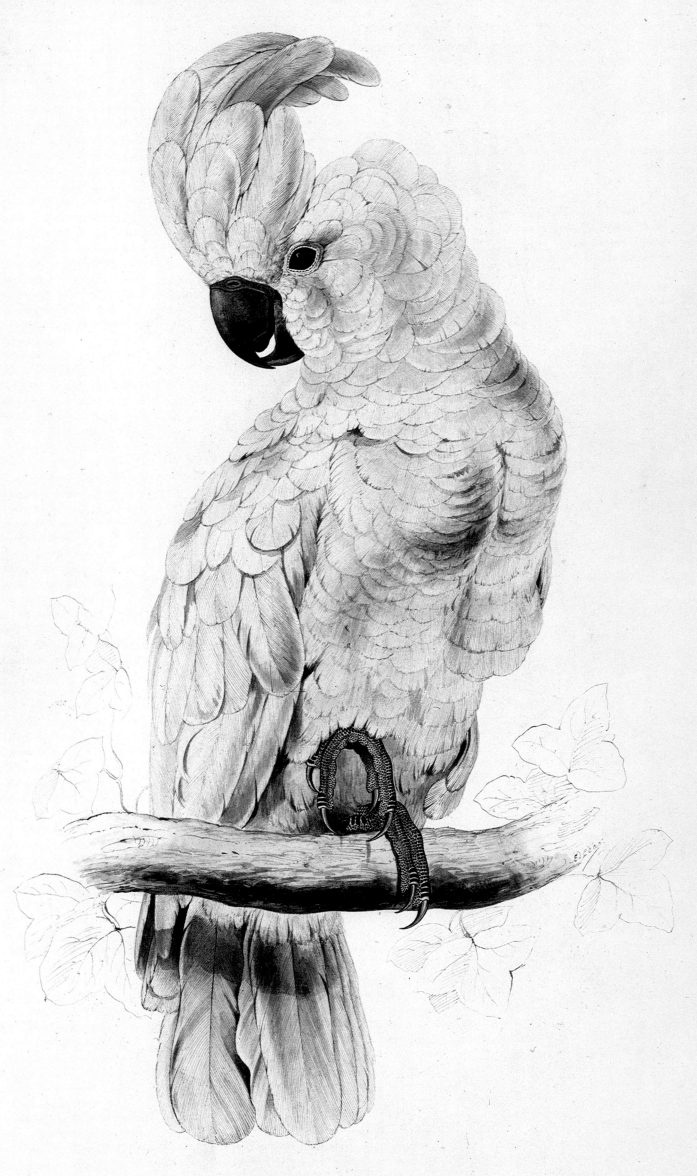

Plyctolophus Rosaceus.

Salmon-crested Cockatoo.

N.º 2

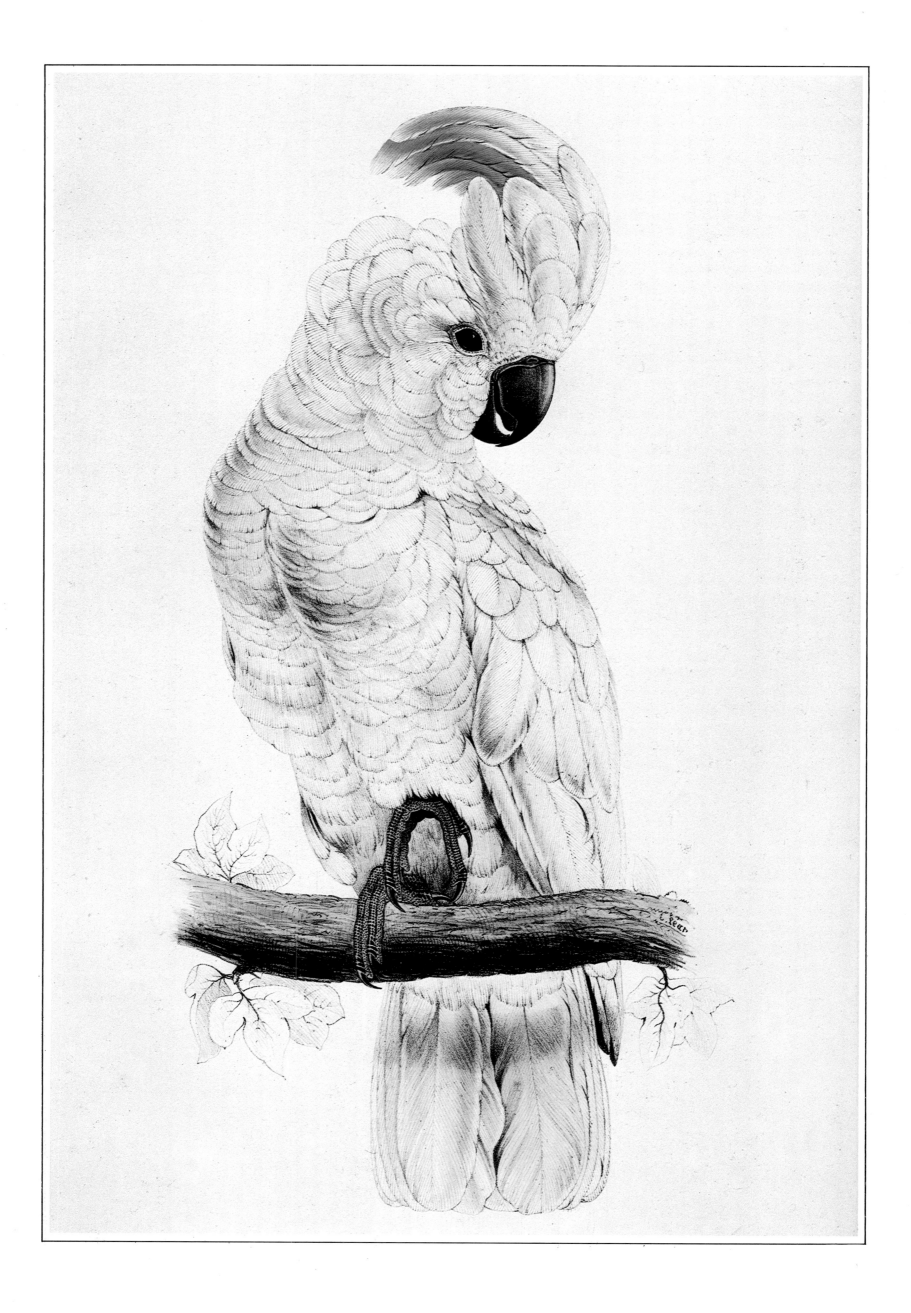

T. was a Tortoise,
So creepy & slow
Though he had but a very
Short distance to go.

(Creepy old Tortoise!

From the Tennyson children's
alphabet.

Brian Reade, formerly Keeper of Prints and Drawings at the Victoria and Albert Museum, has called Lear 'an ornithological Ingres', Sir Sacheverell Sitwell in *Fine Bird Books* 'perhaps the best of all bird painters'. *The Family of Psittacidae, or Parrots* became a prototype and set the aesthetic standards for the great natural histories of the nineteenth century.

William Swainson, himself a lithographer and a student of Audubon, was one of the first to recognize the brilliance of Lear's work. Swainson wrote to Lear from St Albans:

Sir, I received yesterday, with great pleasure the numbers of your beautiful work. To repeat my recorded opinion of it, as a whole, is unnecessary but there are two plates which more especially deserve the highest praise; they are the New Holland Palaeornis, and the red and yellow maccaw. The latter is in my estimation equal to any figure ever painted by Barraband or Audubon, for grace of design, perspective, or anatomical accuracy.

Lear also had the gratification of almost immediate acclaim from his naturalist colleagues. The day after the issue of the first part of the *Psittacidae* he was proposed as an Associate of the Linnean Society. It was November 1830; Lear was still only eighteen years old. His three supporters were Nicholas Vigors, Thomas Bell and Edward Bennett, the same Bennett for whom Lear had worked on *The Gardens and Menagerie of the Zoological Society Delineated*. In the recommendation Lear is described as 'an Artist devoted to subjects of Natural History and now employed in Illustrating the Family of Parrots and in other Zoological Works'.

What these 'other works' are may be guessed, for in a letter to his friend Christopher Empson, dated 1 October 1831, Lear mentions 'a book of Tortoises by a very celebrated Zoologist Thomas Bell and a very kind friend to me'. Bell's kindness may have consisted in part in his recommendation of Lear to the Linnean Society, but his appreciation also extended to giving the young man employment. Beginning in 1831 Lear worked with James de Carle Sowerby, a naturalist and painter, on Bell's *Monograph of the Testudinata*, Lear drawing the lithographs at Hullmandel's after designs by Sowerby. Bell wrote in his prospectus, 'The joint talent of these excellent artists, exhibited in the illustrations of the Psittacidae of the former gentleman, renders it unnecessary to say that the ability of the painter will be only seconded by that of the lithographer and colourist'. The monograph appeared in eight parts between 1832 and 1836, but unfortunately the publisher failed when only two-thirds of the sixty projected plates were finished. The unpublished plates were sold to Henry Sotheran, who eventually published the completed work, with a text by John Edward Gray of the British Museum, in 1872. Although Lear lithographed all the plates, his hand is most evident in the more eccentric-looking tortoises, especially the *Testudo radiata* and the *Chelodina longicollis*. Tortoises are not the most vivacious of creatures, but they are shown in a great diversity of attitudes, sometimes emerging hesitantly from their armoreal carapaces.

Lear's personal copy of Bell's *A History of British Quadrupeds, including the Cetacea*, published in 1837, indicates that Lear continued to work for the zoologist after he left London. The book is

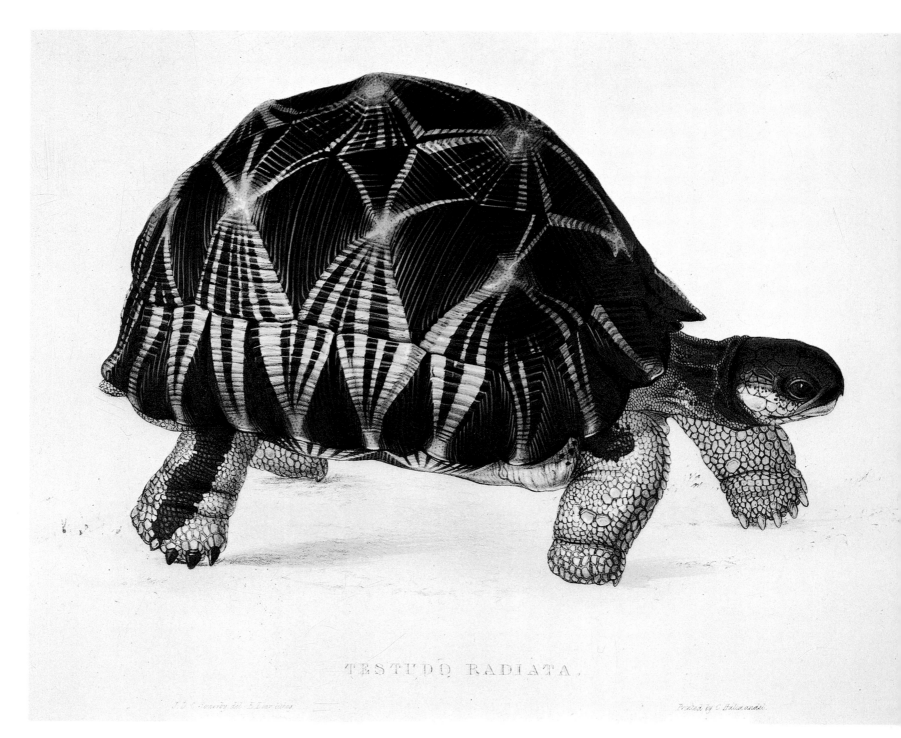

TESTUDO RADIATA.

Testudo radiata, one of Lear's lithographs for Thomas Bell's *A Monograph of the Testudinata*, issued in parts in 1836. John Edward Gray of the British Museum wrote the introduction to the complete version, *Tortoises, Terrapins and Turtles*, published in 1872.

inscribed on the half title: 'Edward Lear, with the author's affectionate regards'. The preface acknowledges the work of 'Mr Dickes and Mr Vasey'; however, seven drawings are signed and dated by Lear, including the Greater Horse-shoe Bat, 'Drawn from nature also on wood by me'. The style of the small wood-engravings is similar to Lear's earlier vignette of lemurs, but the Water Shrew, Ferret Weasel and Hedgehog have an affable charm that might make them acceptable associates of Mole and Ratty in a different incarnation.

Lear's other friends at the Zoological Society also continued to give him employment. For the first volume of *The Transactions of the Zoological Society* in 1835 Lear provided five drawings of animals, including a rabbit, a lion and a kangaroo, and for the second volume in 1841 he drew an illustration for an article by Edward Bennett on bats, as well as another plate of rodents. Lear worked as well on volumes describing the discoveries of two of the great naval expeditions of the time, probably through the influence of these same colleagues. *The Zoology of Captain Beechey's Voyage*, published in 1839, recorded the specimens collected during the

Watercolour dated 1832, probably·a preliminary study for plates of the
Common Shrew and Water Shrew for Thomas Bell's *A History of British
Quadrupeds*, published in 1837.

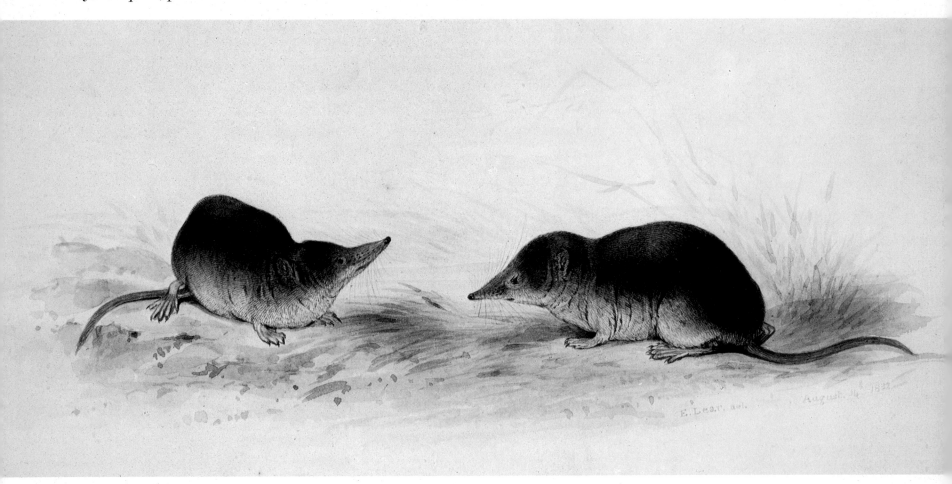

Macropus Parryi, an illustration to an article
by Edward Taylor Bennett in the first volume
of *The Transactions of the Zoological Society*,
Volume I. The side view of the jaw was
included as an aid to classification.

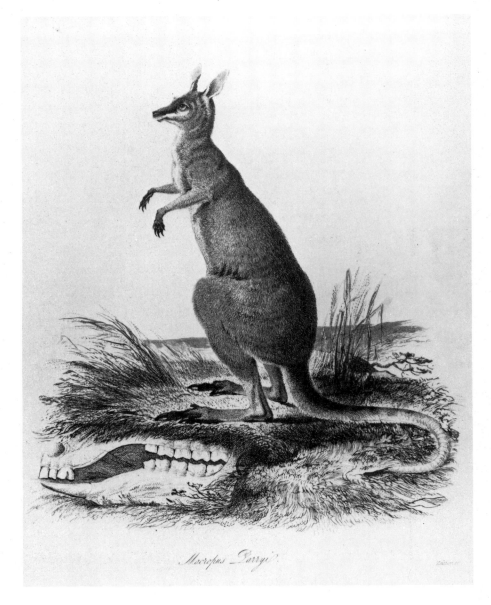

voyage of the HMS *Blossom* in the Pacific and the Bering Strait, with texts by Nicholas Vigors, Edward Bennett and John Edward Gray. There are fourteen watercolour drawings by Lear, including a squirrel, a bat and twelve birds, engraved by John Christian Zeitter and Thomas Landseer, brother of Edwin Landseer, the famous animal painter. Lear also assisted John Gould with fifty drawings illustrating the volume on birds in Charles Darwin's *Voyage of the HMS Beagle*. Although Lear is given no credit, the backgrounds and the larger birds, especially the birds of prey, are in his style.

Lear contributed to several strictly ornithological publications. For Thomas Eyton, a wealthy naturalist and friend of Darwin who privately printed many lavish bird books, he supplied six rather indifferent lithographs for *A Monograph on the Anatidae, or Duck Tribe*, published in 1838, although the work on it had been done some years earlier. Lear's plates in this book lack his usual inventiveness; the figures of ducks, all seen standing in profile, are somewhat static and uninteresting in design. In George Robert Gray's *Genera of Birds* of 1849, Lear is represented by one parrot inscribed 'From Life by E Lear', printed by Hullmandel's new lithotint process which produced the effect of a watercolour drawing and led to the invention of chromolithography.

During the 1830s Lear continued to produce work for Prideaux John Selby. In volumes three and four of Selby and Jardine's *Illustrations of British Ornithology*, completed in 1834, he is

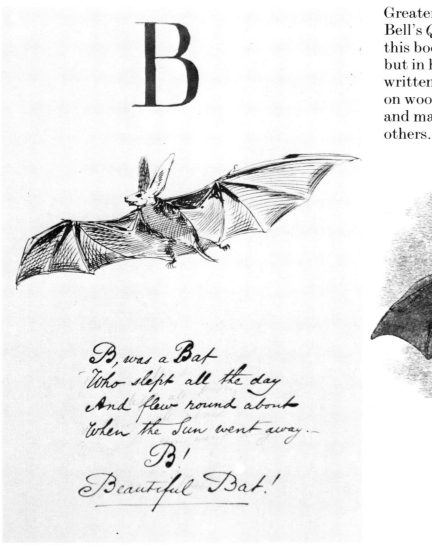

From the Tennyson children's alphabet.

Greater Horse-shoe Bat, from Bell's *Quadrupeds*. Lear's work on this book was unacknowledged, but in his personal copy he has written 'drawn from nature also on wood by me' across this plate, and made similar notes on six others.

represented by seventeen pictures of different types of birds, including pheasants, ducks, falcons, pigeons and finches. Some of the drawings were made in the Zoological Gardens, some in the aviary at Knowsley Hall, while one of the duck plates is borrowed from Eyton's monograph. The drawings engraved by William Lizars are of high quality and Lear must have been pleased to read alongside these pictures comments on his 'accurate pencil' and 'known talents'. The hand-coloured wood-engravings in the modest octavo volumes of Sir William Jardine's *Naturalist's Library*, issued in forty parts between 1825 and 1840, introduced Lear's work to a far wider public. There are many flattering references to him, and 'the beautiful and interesting illustrations by Mr Leer', 'well known to naturalists for his illustrations of Parrots',

PLATE 30

NYMPHICUS NOVÆ HOLLANDIÆ
Red-Cheeked Nymphicus

E.Lear delt Lizars sc

The New Holland Parrakeet from *The Naturalist's Library*, a copy by Lear of his much-praised version in the *Psittacidae*, engraved by William Lizars who also added the filigreed background.

WOOD PIGEON (*Columba palumbus*)
Volume IV *The Birds of Europe*

Overleaf PINTAIL DUCK (*Dafilia urophasianus*)
A Monograph on the Anatidae, or Duck Tribe

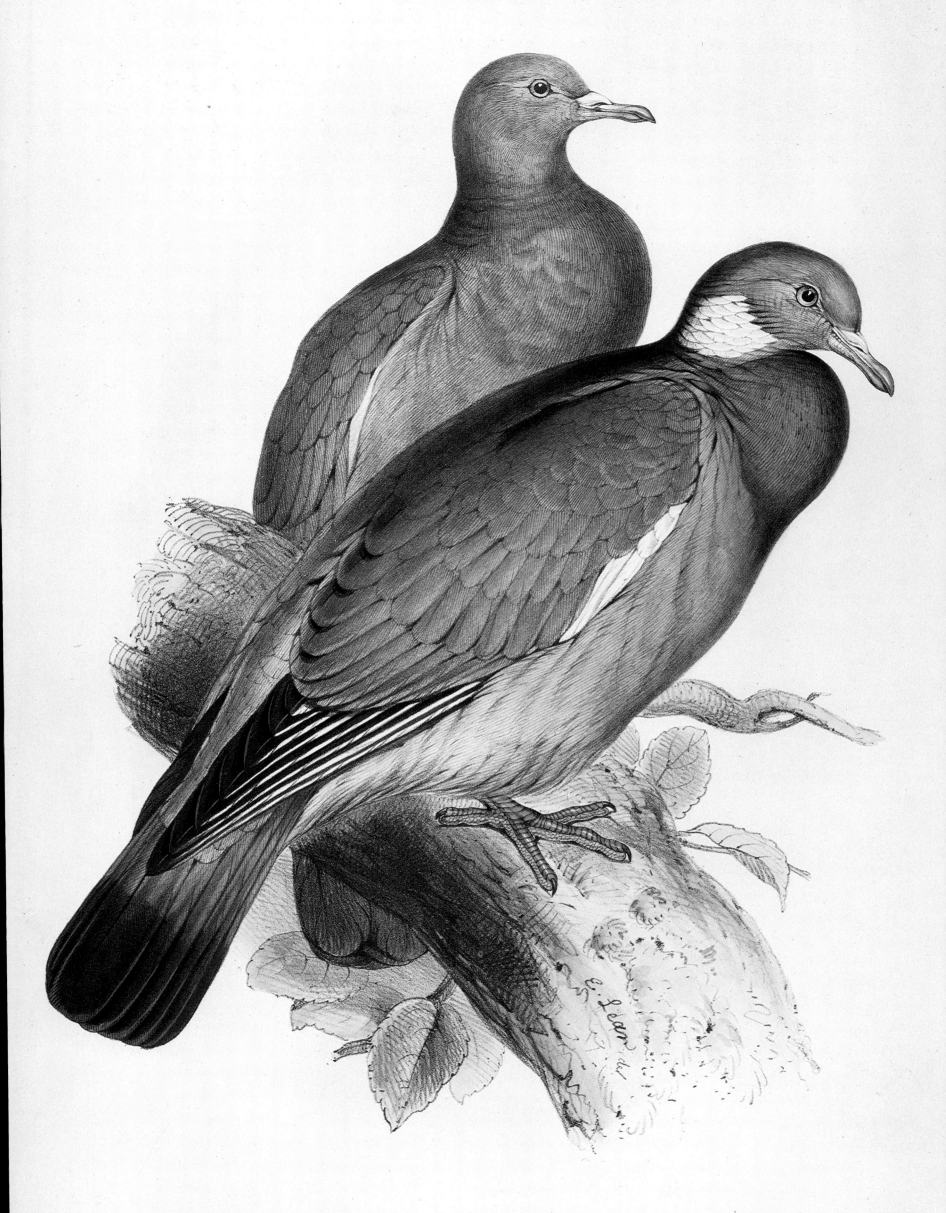

WOOD PIGEON.
Columba palumbus. *(Linn.)*

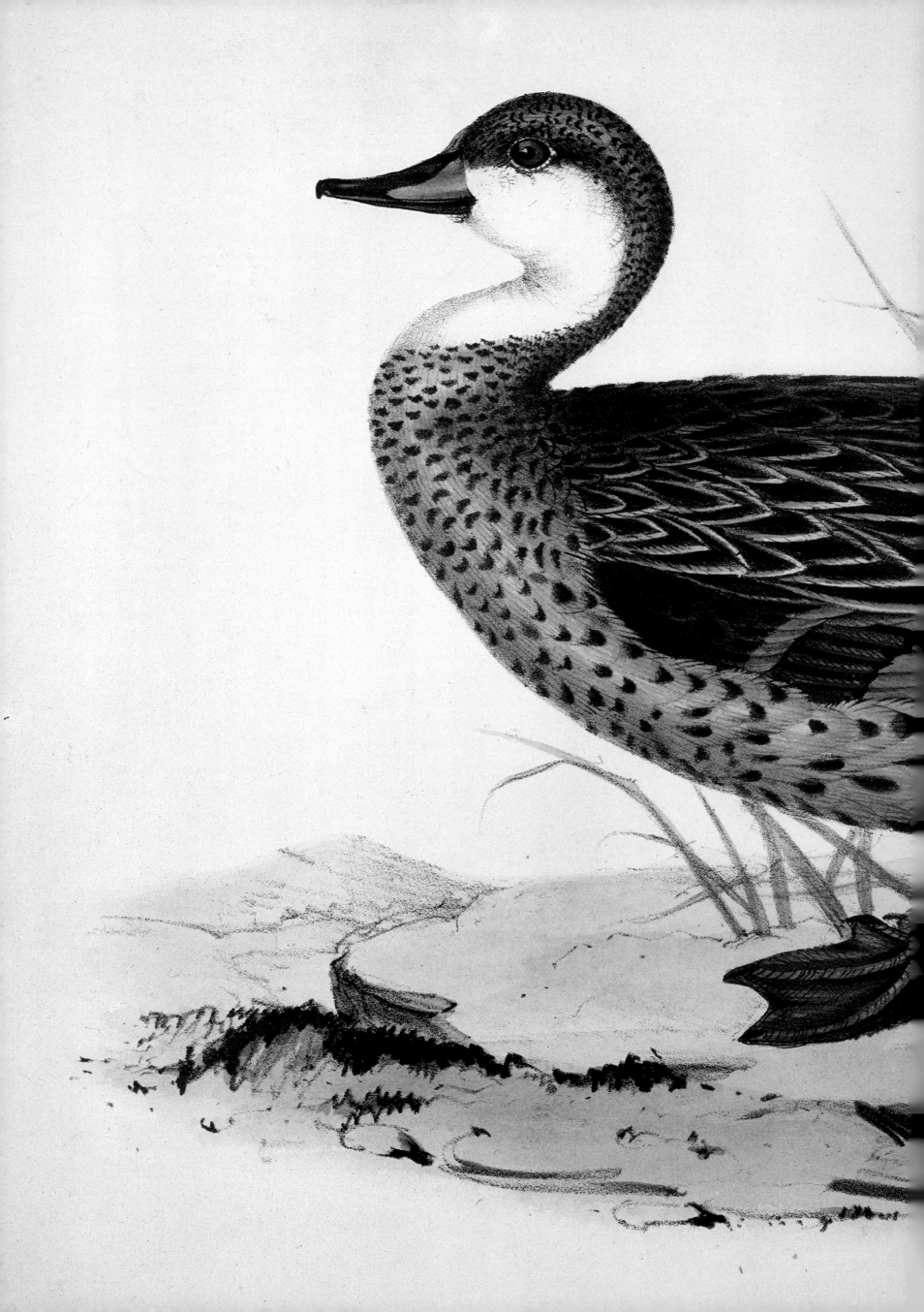

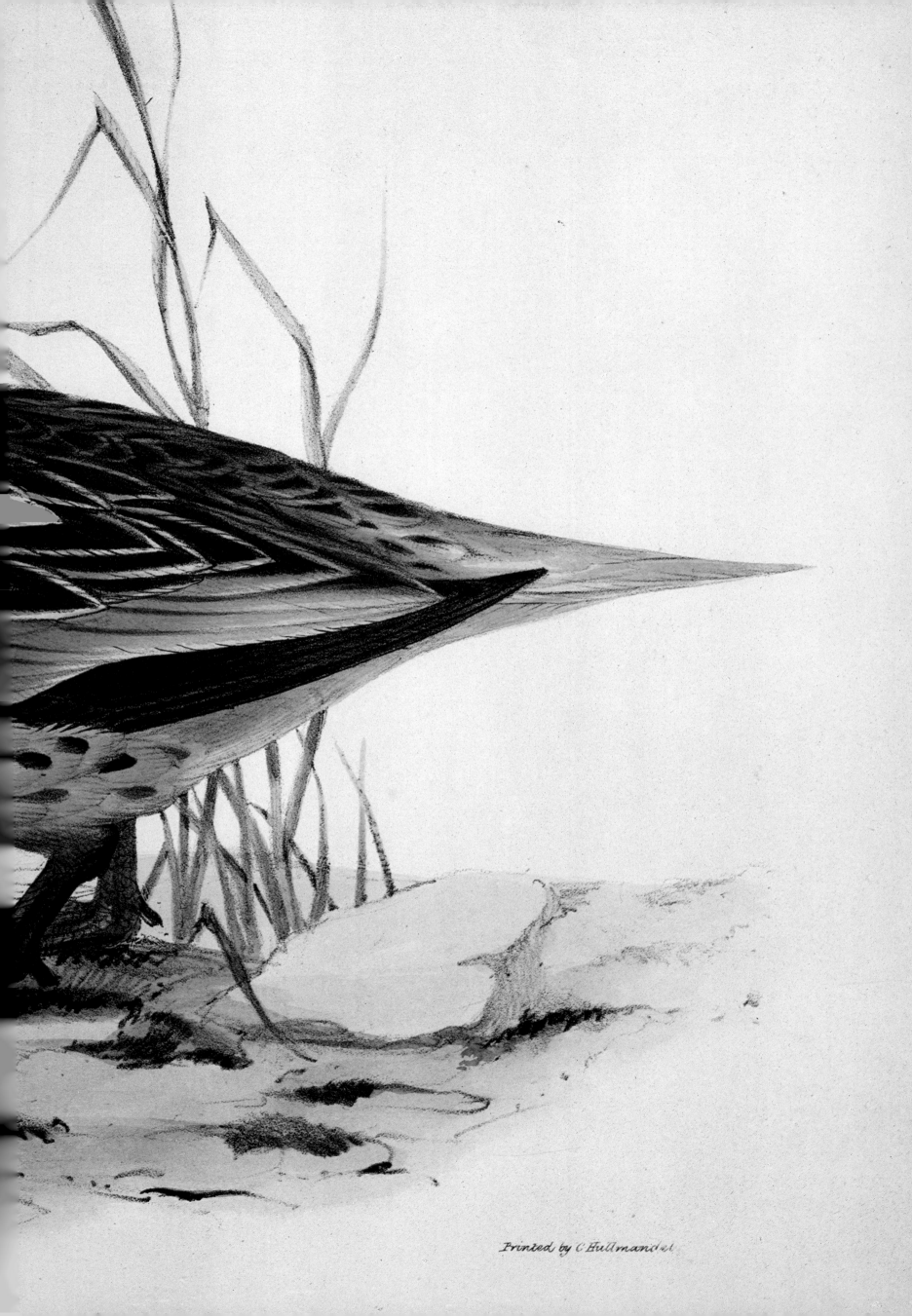

Printed by C Hullmandel

A portrait of Lear in 1840 by William Marstrand.

are highly praised, although the plates themselves are not much above the routine level of the time. A letter to Lizars dated June 1834 survives in which Lear agrees to draw fifteen birds for £10, and in a letter of 1836, written while Lear was at Knowsley, he notes a further request from Lizars. Lear contributed drawings to the volumes on felines and monkeys and thirty plates each to the volumes on parrots and pigeons, whose texts were written by Selby. Many of the parrots are based on earlier studies, but in the small wood-engravings of Lizars most of the spirit of Lear's original work has been lost. The Blue and Yellow Maccaw is a shadow of its former self, while the backgrounds have been prettified with feeble vignettes of tropical scenery. The New Holland Parrakeet reappears, lost amidst a mass of gratuitous greenery.

KESTREL (*Falco tinnunculus*)
Volume I *The Birds of Europe*

Most of Lear's birds shown at rest are in characteristic poses. The introduction of a bloodied victim in this plate is a dramatic detail unusual in his work but common in Continental bird plates.

Overleaf MARSH HARRIER (*Circus rufus*)
Volume I *The Birds of Europe*

Bird illustrators often used pairs of birds to demonstrate differences in the gender or development of the species. Here the adult stands in front of the immature bird.

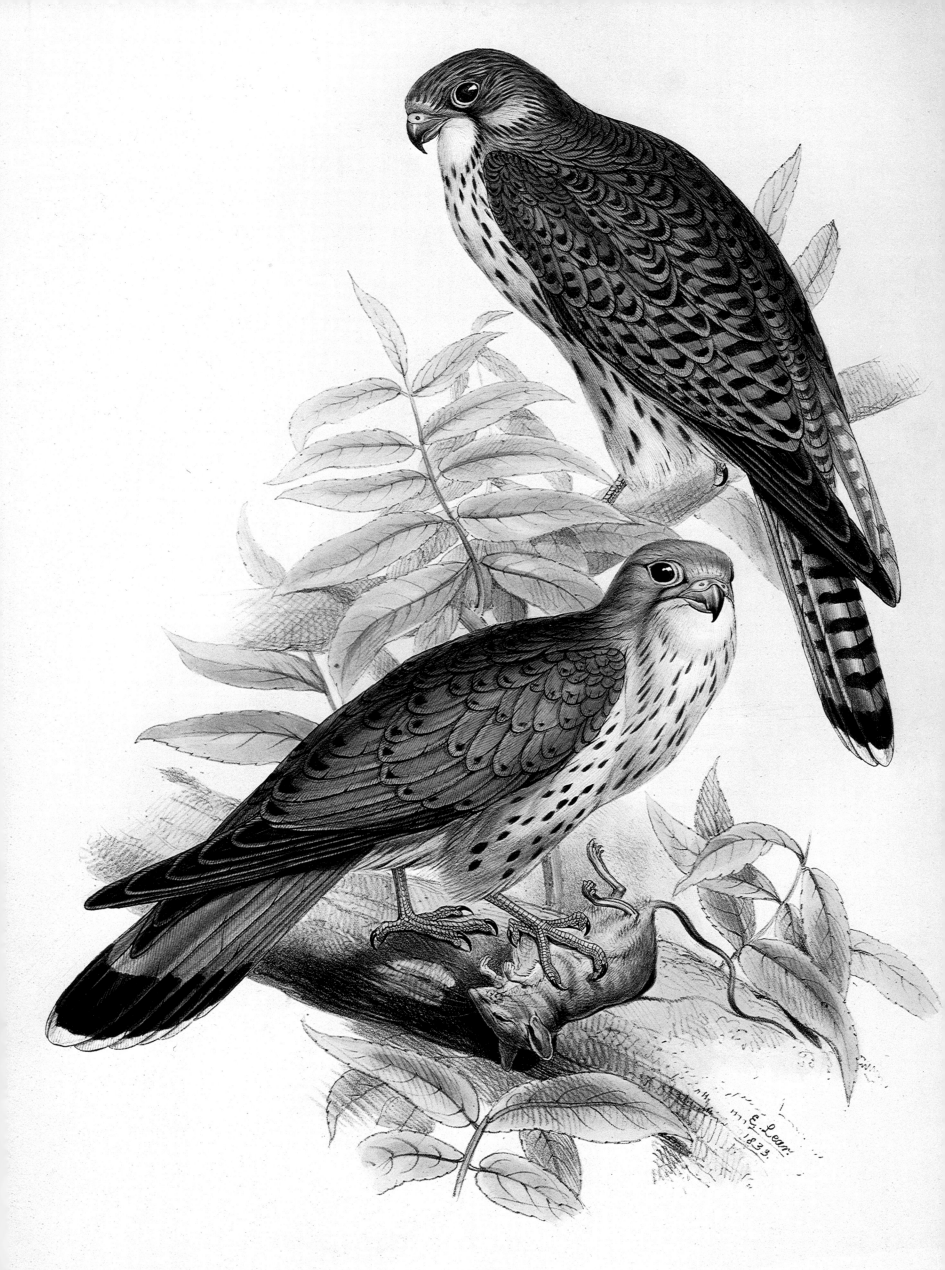

KESTREL.
Falco tinnunculus; (Linn.)

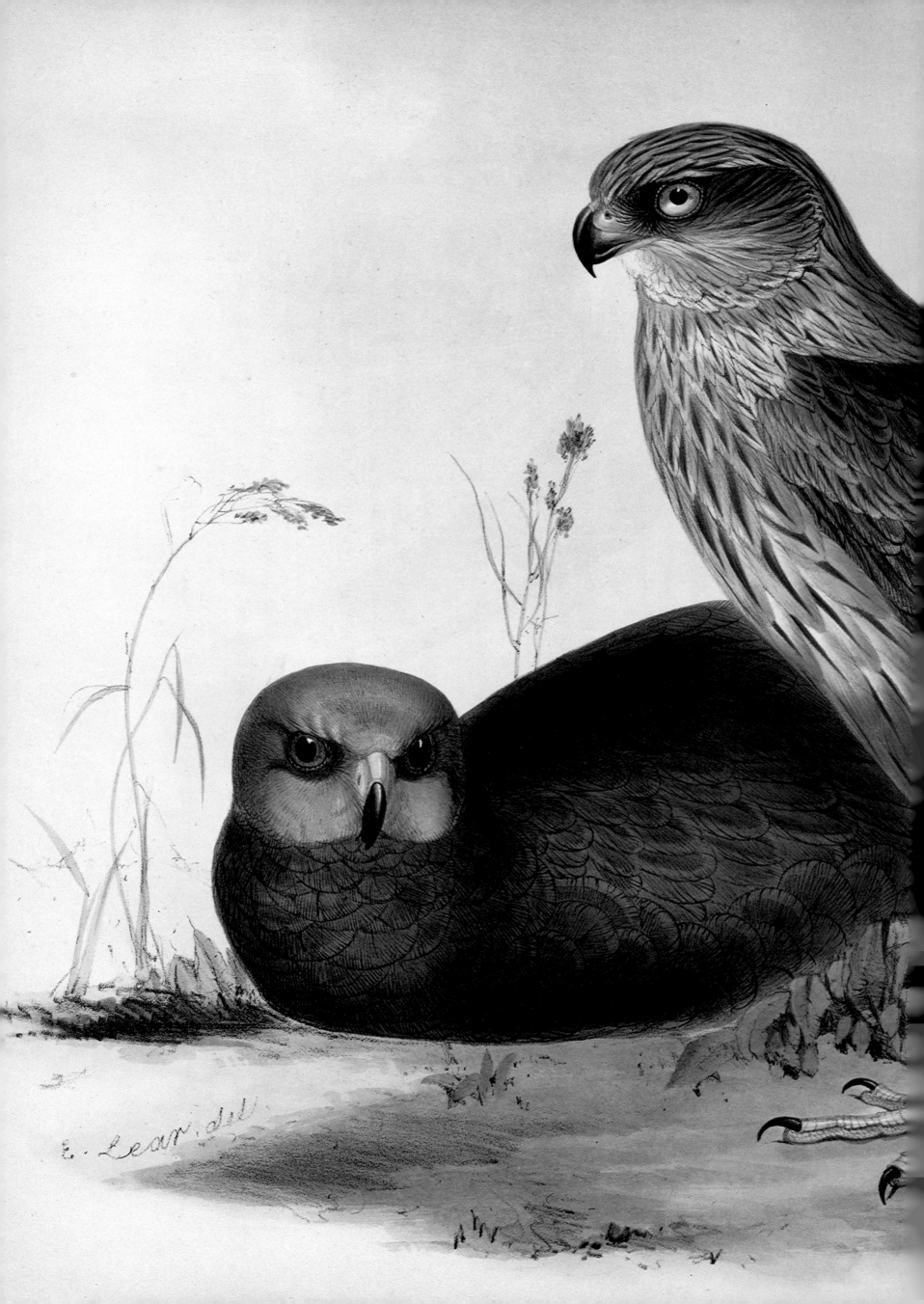

E. Lear. del

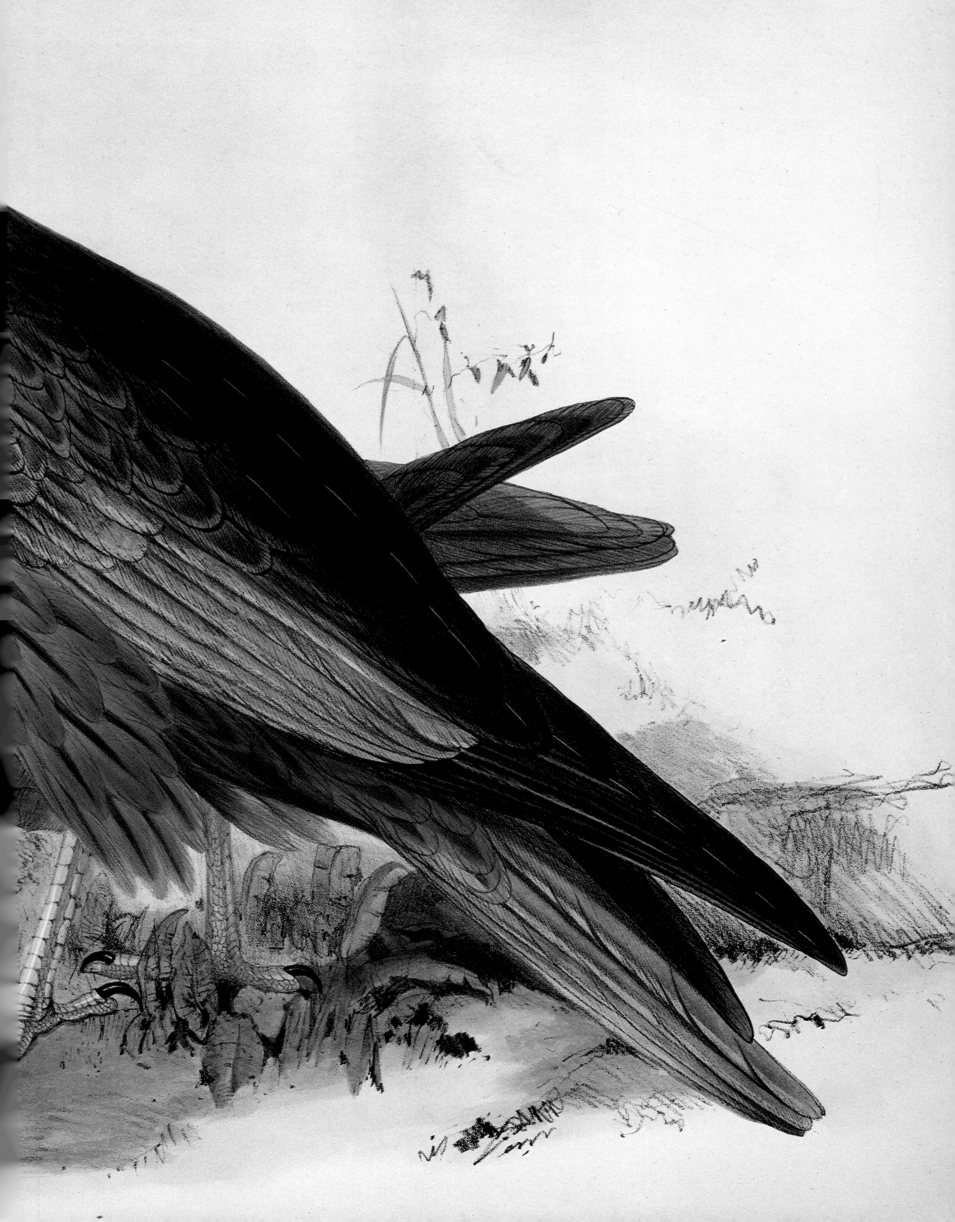

John Gould, however, was the quickest to recognize and exploit the potential of Lear's early work. The son of a gardener at Windsor Castle, later an assistant gardener himself at Ripley Castle in Yorkshire, Gould was hired by Nicholas Vigors in 1827 to work for the Zoological Society as a taxidermist. A shrewd entrepreneur and a ruthless businessman, Gould became one of the great naturalist publishers of the nineteenth century, producing forty folio volumes of birds containing nearly three thousand plates. Yet Gould was a naturalist of no great distinction and little artistic ability. He relied at first on the talents of his wife Elizabeth and on those of Lear, later on the work of William Hart, Henry Richter and Joseph Wolf. He was totally without conscience in claiming credit for the work of others, seldom acknowledging their contribution; in many cases he erased the signatures of artists from plates, substituting his own or that of his wife. Joseph Wolf, who produced many fine drawings for Gould's later volumes, described him as 'a rough old fellow ... the most uncouth man I ever knew'. Lear endured a long period of unprofitable collaboration with Gould. He was a hopeless businessman, Gould an unscrupulous and ambitious one, and whatever transactions took place between them would have been heavily in Gould's favour. In 1881, after he had heard of Gould's death, Lear recalled:

He was one I never liked really, for in spite of a certain jollity or bonhommie, he was a harsh and violent man. At the Zoological S. at 33 Bruton St. – at Hullmandels – at Broad St. ever the same persevering hardworking toiler in his own (ornithological,) line, – but ever as unfeeling for those about him. In the earliest phase of his bird-drawing he owed everything to his excellent wife, & to myself, – without whose help in drawing he had done nothing. About 1830 ... I went with him to Rotterdam, Berne, Berlin and other places – but it was not a satisfactory journey;– and at Amsterdam we laid the foundation of many subsequent years of misery to me.

Lear may first have met Gould when he borrowed stuffed specimens for the *Psittacidae*. When Lear's finances failed, Gould, eager to exploit any opportunity, wrote to Sir William Jardine offering to complete the unfinished parts; but this scheme does not seem to have met with encouragement. Gould certainly realized the attractiveness of the folio lithographs in the *Psittacidae* which, as Lear said, 'led to all [his] improvements', for he used that book as a model for all of his own, which also were printed by Hullmandel. In 1830 Gould received a collection of skins of Indian birds which he stuffed and used as models for his first publication, *A Century of Birds from the Himalayan Mountains*. Lear drew all of the backgrounds and touched up the lithographs by Elizabeth Gould, receiving no acknowledgment, but listed, improbably, as a subscriber. In 1834 Lear also contributed the ten best plates to Gould's first treatise on a single family of birds, *A Monograph of the Ramphastidae, or Family of Toucans*. His work is not credited and in the 1854 edition of the book his signature is actually obliterated from the body of several plates, some of which are inscribed at the bottom 'Drawn From Life by J&E Gould'.

Lear added the backgrounds to Gould's *Icones Avium* of 1837, a miscellany depicting newly-discovered species, and to his *Monograph of the Trogonidae, or Family of Trogons* of 1838, again without

recognition. Part One of *The Birds of Australia*, issued in 1838, contains a plate of the New Holland Parrakeet 'copied by permission' from the *Psittacidae* and one other lithograph signed by Lear. But Lear's association with Gould is still primarily remembered for the work he contributed to Gould's *magnum opus*, *The Birds of Europe*, printed by Hullmandel in five parts between 1832 and 1837; it is probably in connection with this enterprise that Lear and Gould made their uncongenial tour of continental zoos. The small, colourful, pretty birds, the warblers, finches and thrushes, were painted by Elizabeth Gould from sketches by her husband, and they are easily identifiable by the fact that they manage to look like stuffed specimens even when copied from living animals. The large, monstrous, sinister and eccentric birds, the eagles, vultures, falcons, owls, storks, pelicans and cranes, are by Lear. They are certainly among the most remarkable bird drawings ever made, and it is evident that Lear endowed them with some measure of his own whimsy and intelligence, his energetic curiosity, his self-conscious clumsiness and his unselfconscious charm. No bird has ever stared forth from a page with such startling self-possession as his massive Eagle Owl, nor consorted in such

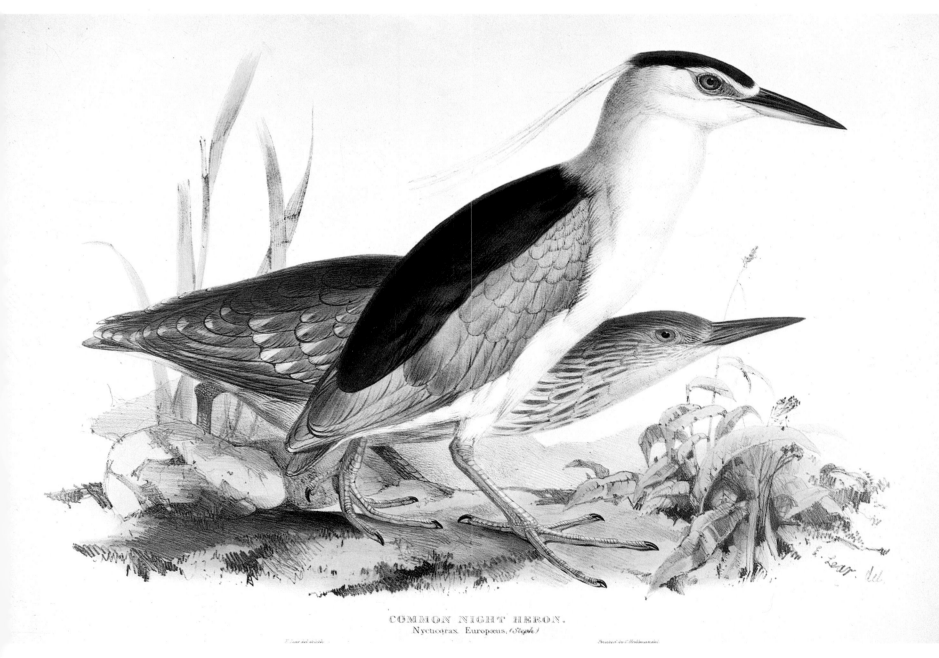

COMMON NIGHT HERON.
Nycticorax. Europæus, *(Steph.)*

COMMON NIGHT HERON (*Nycticorax europaeus*)
Volume IV *The Birds of Europe*

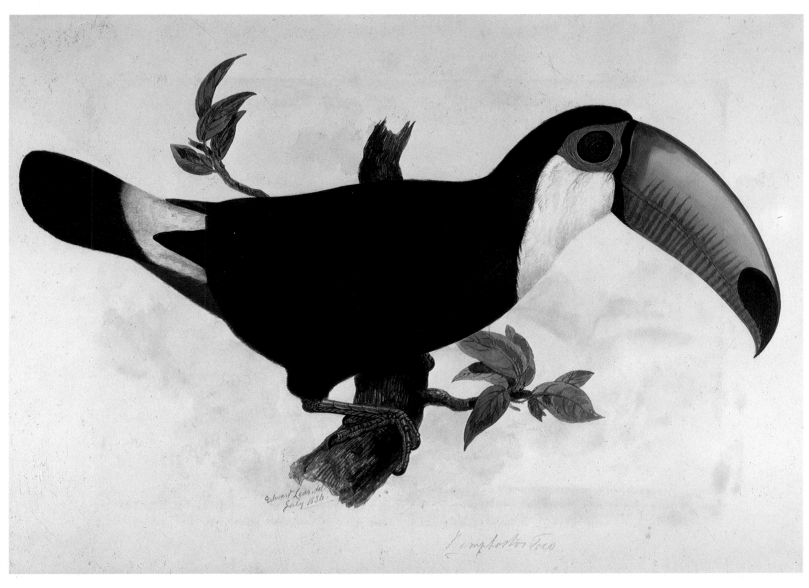

TOCO TOUCAN (*Ramphastos toco*)
A watercolour dated 1836 of one of the many South
American toucans collected by the Earl of Derby in
the Knowsley Hall aviary.

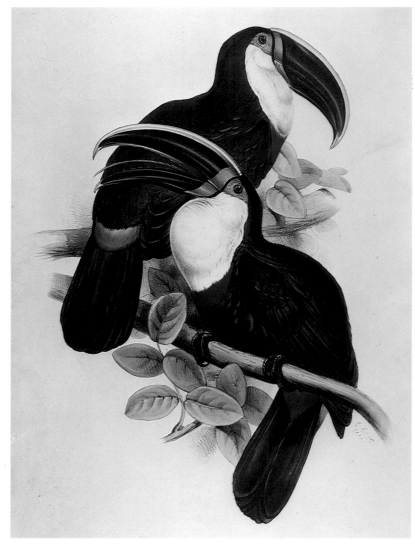

Right CULMENATED TOUCAN (*Ramphastos culmenatus*)
A Monograph of the Ramphastidae, or Family of Toucans

Lear produced ten plates for this book. In the 1854
edition, some were omitted, others credited to Gould
and his wife, Elizabeth.

Opposite TOCO TOUCAN (*Ramphastos toco*)
A Monograph of the Ramphastidae, or Family of Toucans

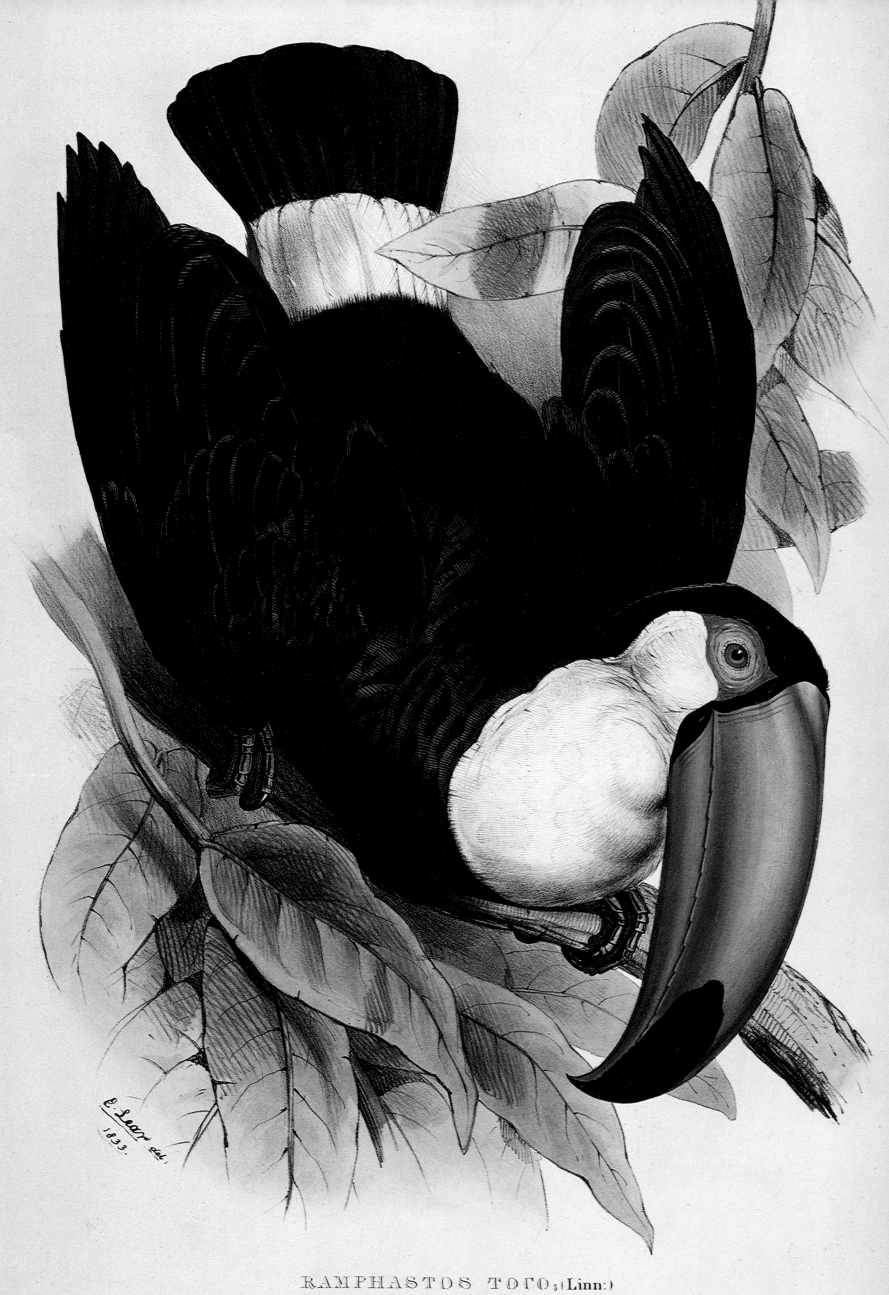

RAMPHASTOS TOCO; (Linn:)
Toco Toucan.

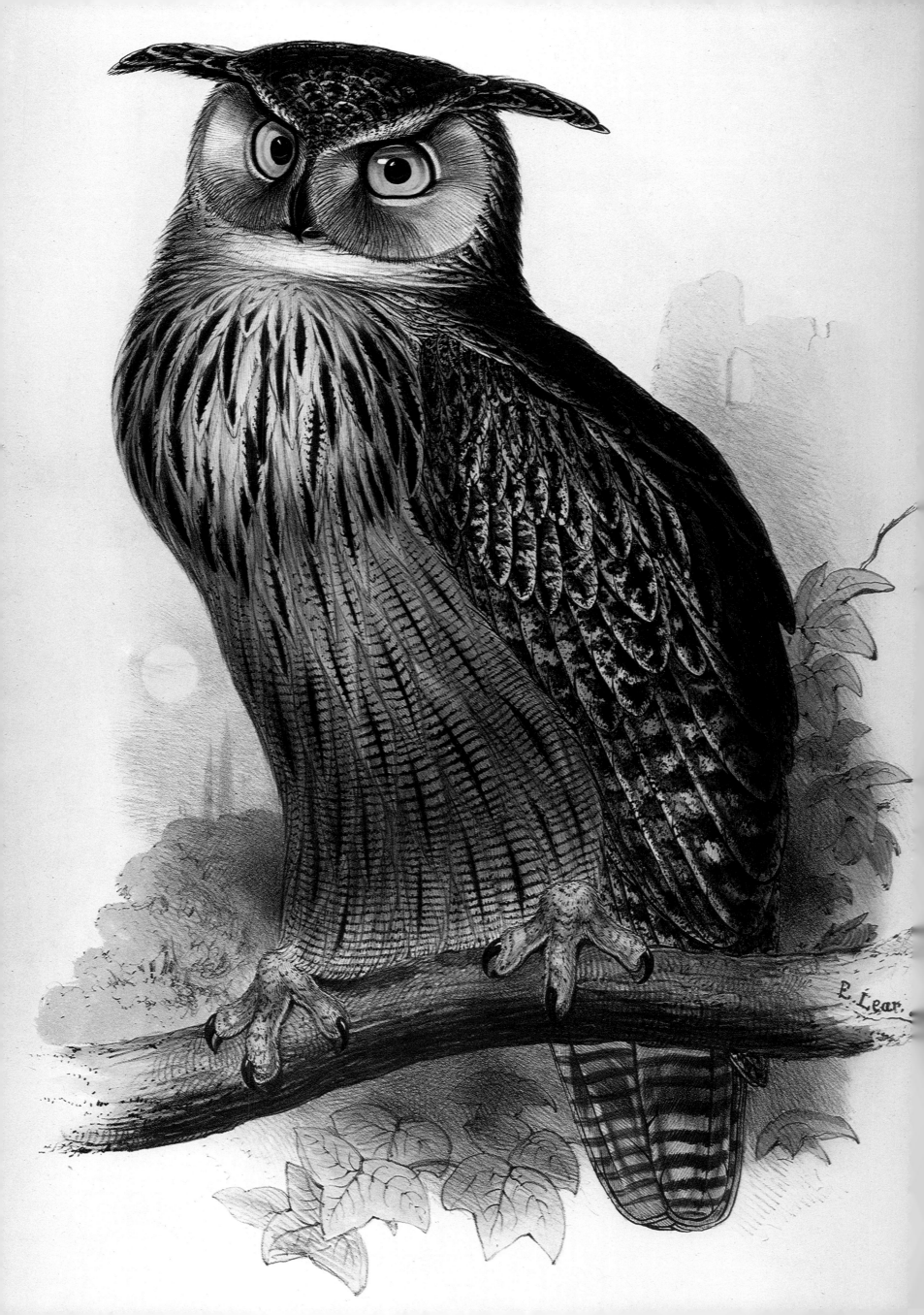

grotesque conjugal bliss as his Dalmatian Pelican. His genial long-limbed storks, balletic flamingos and precariously poised cranes are humorous and nervously elegant. The owls and cranes lack the rare delicacy of some of his parrots, but in many ways Lear was more understanding of the idiosyncratic than of the exquisite. The large bold designs with which he has filled his plates transcend period style and aesthetics. With his Nonsense and some of his watercolours, these illustrations remain the best of his work.

Within his lifetime Lear's contribution to *The Birds of Europe* was forgotten. He is briskly passed over in Gould's preface – 'his abilities as an artist so generally acknowledged that any comments of my own are unnecessary' – and some of his plates were copied in *The Penny Magazine*, where they stand at the head of articles in which his name is not even mentioned. The Goulds were later to mimic his work, but they produced no more than banal and superficial parodies. Some of his imitators paid him the compliment of more proficient plagiarism. A plate in Thomas Varty's coloured lithographs in *The Series of Domestic and Wild Animals* shows a

E

E was an Eagle
Exceedingly regal,
Who sat on a rock,
And stole lambs from the flock.
e!
Dreadful old Eagle!

The Visibly Vicious Vulture
who wrote some Verses to a Veal-cutlet in a
Volume bound in Vellum

EAGLE OWL (*Bubo maximus*)
Volume I *The Birds of Europe*
An awesome bird of prey, Lear's Eagle Owl occupies a realm somewhere between nature and the imagination. His most famous bird plate was, paradoxically, drawn from a stuffed specimen.

parrot and parakeet lifted direct from *The Naturalist's Library*. Beverly Morris's *British Game Birds and Wild Fowl* contains an assortment of Lear's geese in reverse. The Reverend Francis Morris was more discerning in his taste; recognizing their superiority, he selected Lear's owls, birds of prey, storks and cranes for his *History of British Birds*.

In 1837 Lear's parrots made their Continental début in Bourjot Saint-Hilaire's *Histoire Naturelle des Perroquets*. Some of the plates are 'd'après Lear', but he receives no credit for 'Le Cacatoës de Leadbeater', 'cette espèce vraiment magnifique. . . . Ces trois beaux compagnons semblaient se jouer sur leur perchoir, en se congratulant de leur belle robe, pendant que toute la société les regardait et que chaque enfant s'écriait: *oh beautiful bird!*' (No doubt the author was unaware of using poetic licence, since Mr Leadbeater was a well-known dealer in bird skins.) The migration of Lear's plates was a bizarre tribute, the only one he received for years of disciplined, dedicated art. It is understandable that he later seldom mentioned the bird books on which he had worked.

Lear's career as a naturalist was not limited to the illustration of zoological treatises, and in the 1830s, at about the same time that he met John Gould, he made another acquaintance whose

The Seven Storks, who quarrelled over a frog, fought for a week, and 'pecked each other to little pieces, so that at last nothing was left of any of them except their bills'.

From *A History of the Seven Families of the Lake Pipple-Popple*.

There was an Old Man of Dumblane,
Who greatly resembled a Crane;
But they said, – 'Is it wrong,
Since your legs are so long,
To request you won't stay in Dumblane?'

BLACK STORK (*Ciconia nigra*)
Volume IV *The Birds of Europe*

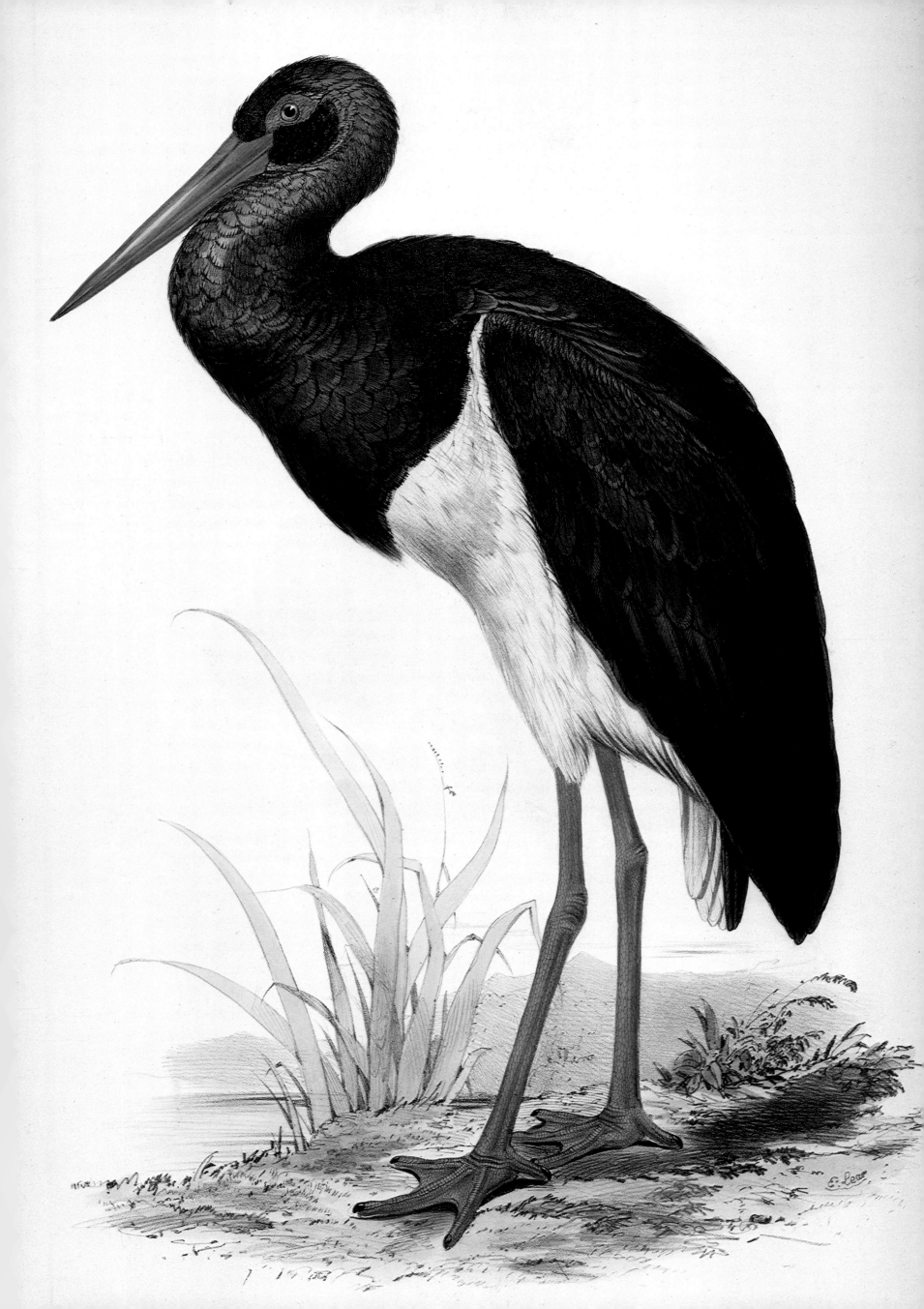

friendship was to alter his circumstances in a quite dramatic fashion. Edward Lord Stanley, President of the Zoological and Linnean Societies, was a keen amateur naturalist and had assembled at Knowsley Hall, his family seat near Liverpool, the largest and finest private menagerie in England. His father, the twelfth Earl of Derby, was also passionately interested in animals, but his enthusiasms were more sporting than scholarly; he bred and trained fighting cocks and race horses and it was he who initiated the famous Derby meetings on Epsom Downs. The inclinations of Lord Stanley, who succeeded as the thirteenth Earl in 1834, were academic. His study of natural history, begun in childhood, developed into serious scientific research and an ambitious scheme to naturalize an unprecedented variety of exotic birds and animals. Formerly the collection at Knowsley, like those of many other great houses, had been a picturesque ornament to the estate. Lord Stanley enlarged the menageries and aviaries and devoted many years of labour and a reported £10,000 a year of his income to their maintenance and extension. When Joseph Wolf visited the menagerie in 1850, he was amazed to find it larger than the Zoological Gardens in London, and much more splendid:

Whatever the most lavish expenditure, the influence of the head of a great house, untiring foreign collectors and correspondents, extravagant enthusiasm, and dogged pertinacity could do to enrich the collections, living and dead, had been done. There was, perhaps, nothing to equal them at that time, and I suppose that, in many respects, they have not been surpassed.

In its prime the collection must have been extraordinary; various enclosures, paddocks, aviaries and plantations spread over nearly one hundred acres of land and vast expanses of water. Thirty

'Verily I am an odd bird.' From a letter to Lord Carlingford (Chichester Fortescue), September 1863.

FLAMINGO (*Phœnicopterus ruber*)
Volume IV *The Birds of Europe*

Overleaf DALMATIAN PELICAN (*Pelicanus crispus*)
Volume V *The Birds of Europe*

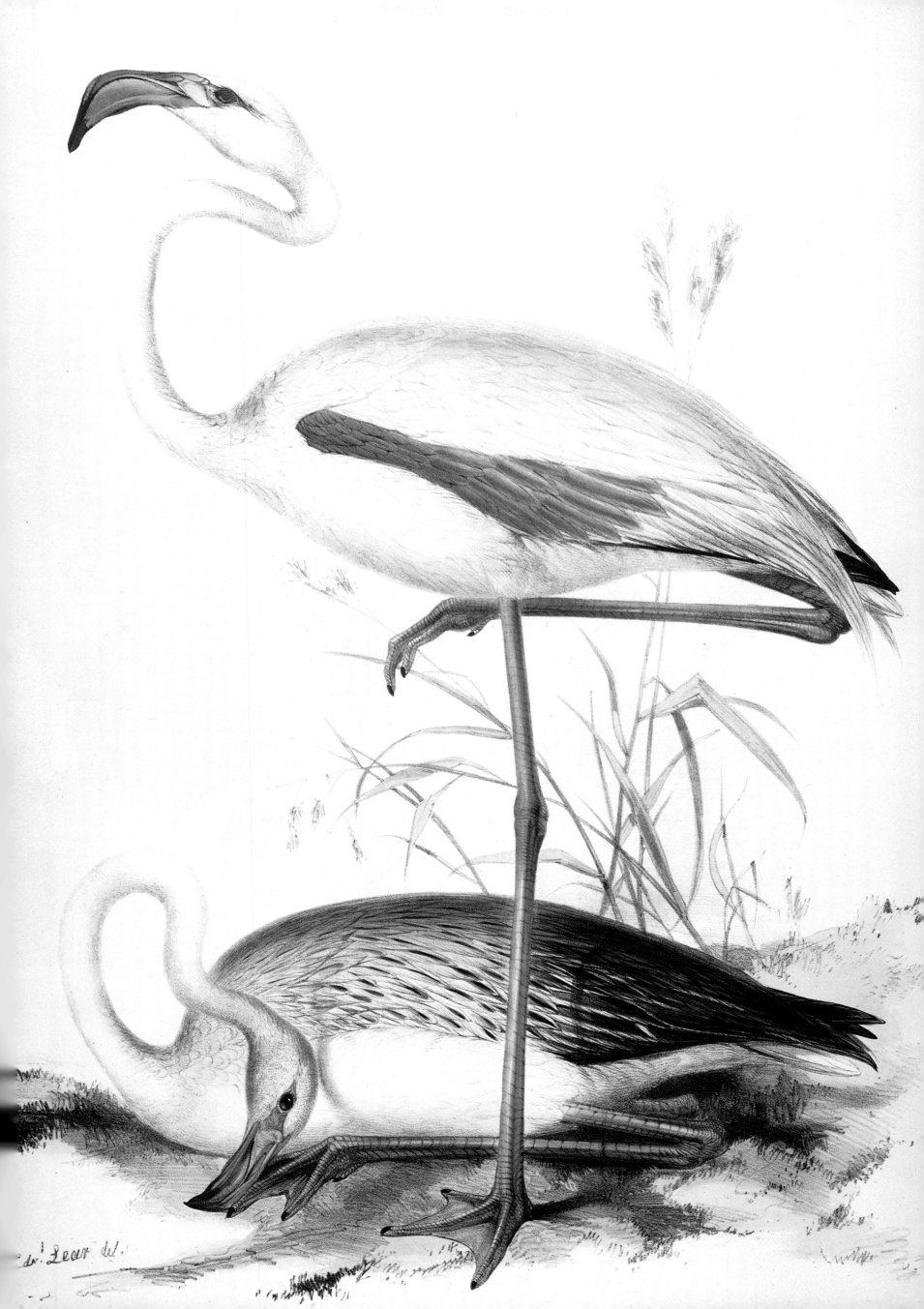

dr Lear del.

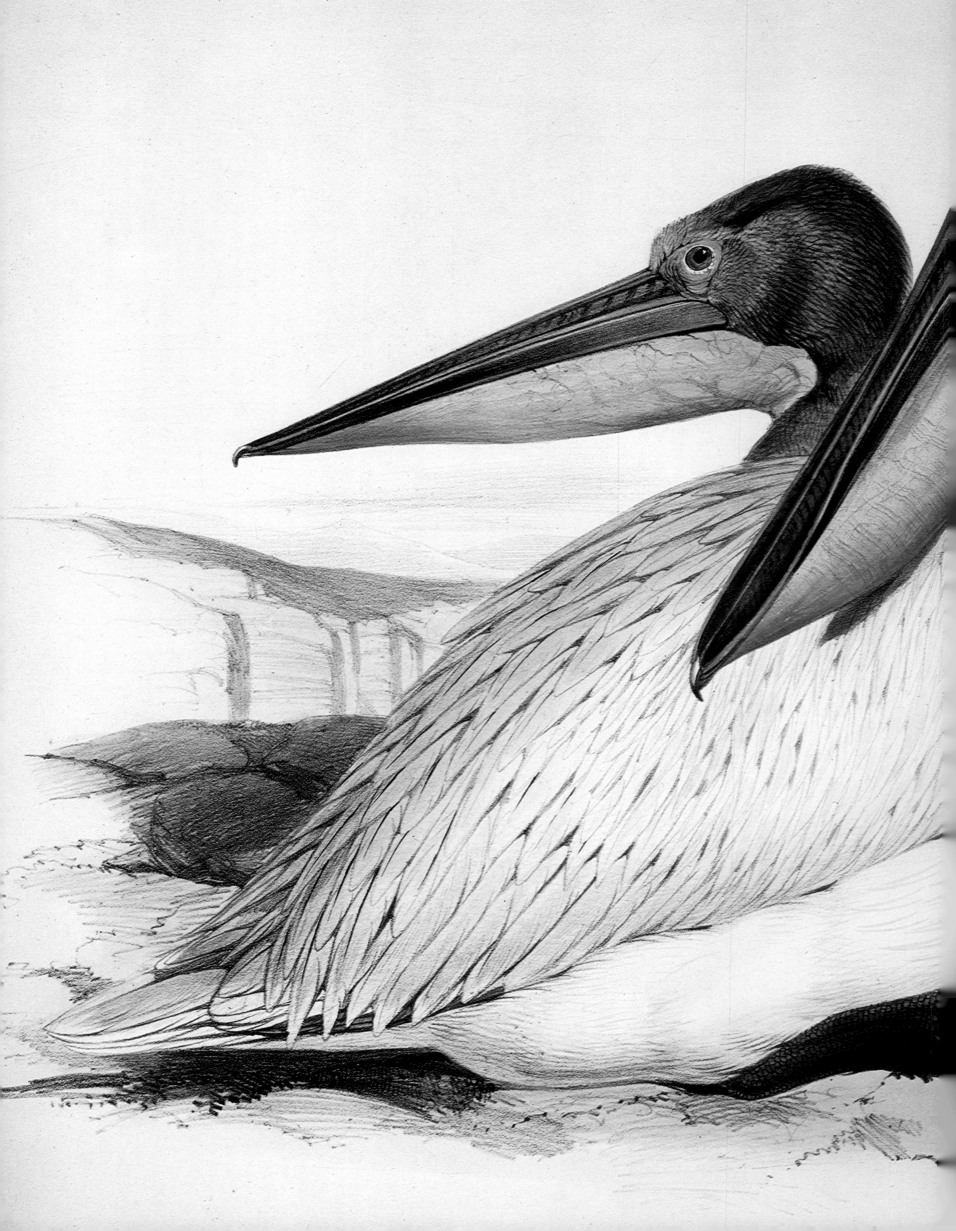

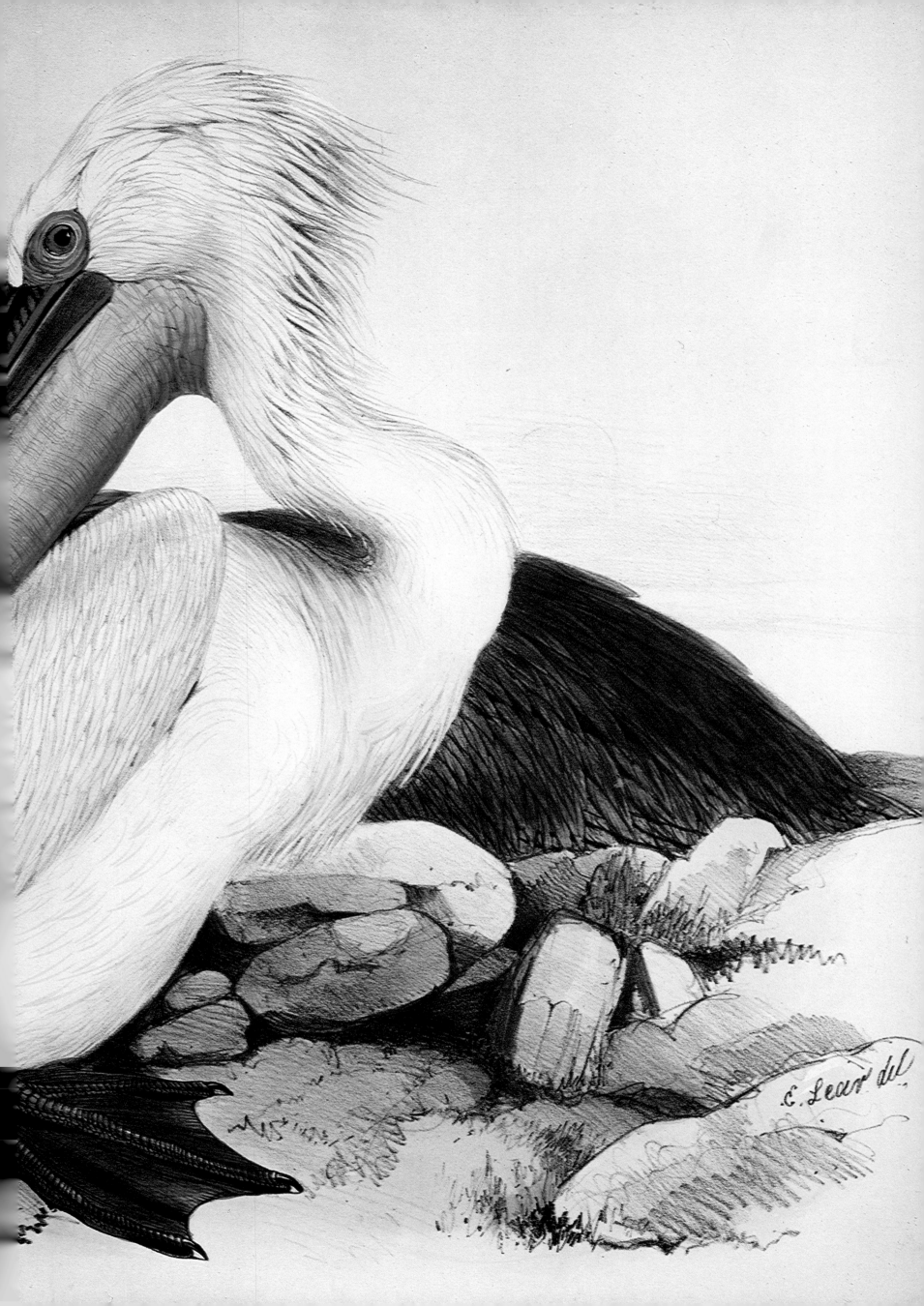

C. Lear del.

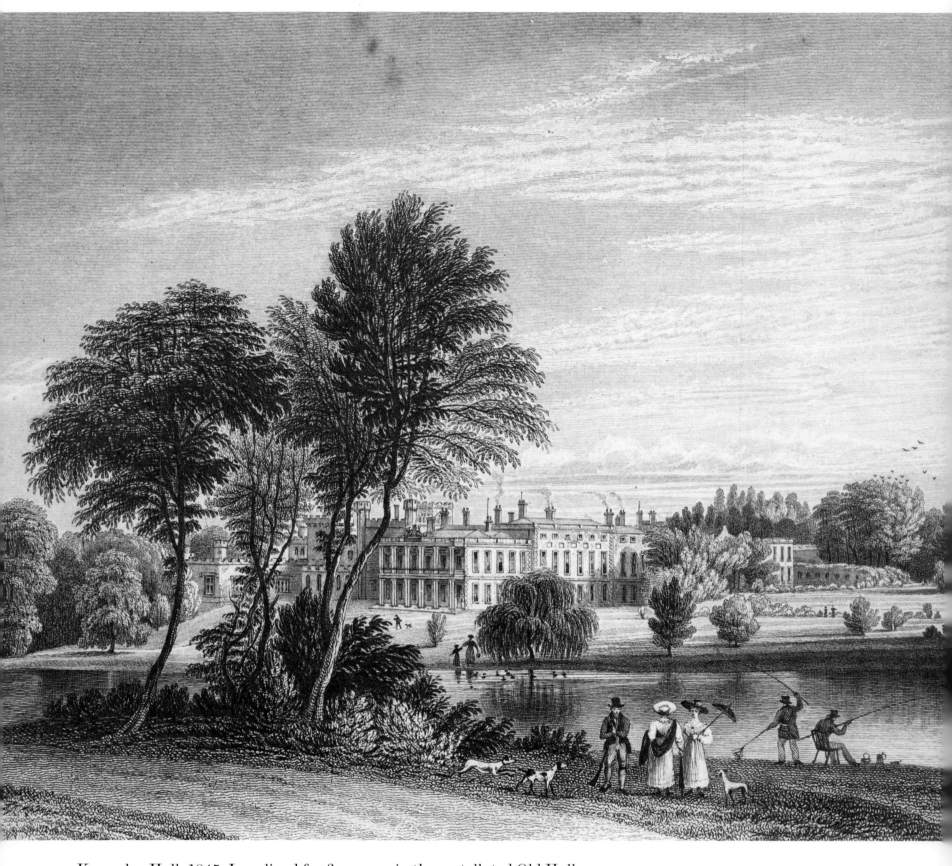

Knowsley Hall, 1845. Lear lived for five years in the castellated Old Hall,
which appears through the trees on the left.

attendants were employed to look after the birds and animals which in 1851 comprised 345 mammals of 94 species and 1,272 birds of 318 species, of which 756 individuals had been bred at Knowsley. Lord Stanley was in touch with over twenty agents throughout the world who sent him new specimens for the live collection at Knowsley and skins for the musuem. He also financed expeditions to Africa, Honduras and the Hudson Bay territories, and to Germany, Norway and Sweden.

Lord Stanley's notes in *Gleanings from the Menagerie and Aviary at Knowsley Hall* reveal that his collection was no extravagant hobby or dilettante diversion. He took an active interest in the state of his menagerie; a perceptive observer of animal behaviour, he kept detailed notes on the identification of new species, and on his efforts to procure new animals and adapt them to the English climate. He records their condition, frets over their health, rejoices over their sporadic mating and mourns their frequent demise. He is dubious about the legitimacy of an attempt at crossbreeding: 'The Bohemian Hen put to the male *Phasianus versicolor* has laid, but it is doubtful if the egg is by him.' He takes a particularly paternalistic interest in the breeding of new species and records the progress of newly-hatched chicks with pride, writing to a friend, 'You will be glad to hear that my eight young Orenoco Goslings are all doing well', and again, 'My Black Swans are proceeding famously ... pretty quick laying twelve eggs in less than twelve months!' He also mentions the Maned Goose, adding that 'it figured in Lear's drawing, who was much amused by its manner of swelling out the breast like a Pouter Pigeon, which he represented'.

Lord Stanley's single-minded absorption in his collection extended to his other concerns as well. He acquired a taste for animal art, and to the great picture galleries in his ancestral home he added many contemporary paintings that reflected his own enthusiasms. A nineteenth-century catalogue of art works lists as his contribution many portraits of animals bred successfully at Knowsley and a canvas of epic proportions entitled *Wild Ass, Zebras and Half-Bred Produce*. In 1832 Lord Stanley conceived the notion of illustrating his menagerie, hoping that the drawings would provide a record which would be of aid in the identification and classification of new species. The illustrations seem to have served this purpose and many of Lear's watercolours are inscribed with scientific names which had not been invented at the time the animal was drawn. Stanley consulted George Robert Gray of the British Museum for a suitable illustrator and Gray recommended Edward Lear. The two men had already met when Lear had borrowed a parrot from Stanley to augment his selection for the *Psittacidae*, to which Stanley was one of the subscribers. He went straight to the Zoological Gardens, observed Lear at work sketching birds and engaged him on the spot.

Overleaf COMMON PHEASANT (*Phasianus colchicus*)
Volume IV *The Birds of Europe*
Lear seldom painted game birds. His splendid male is in front, the subdued female behind.

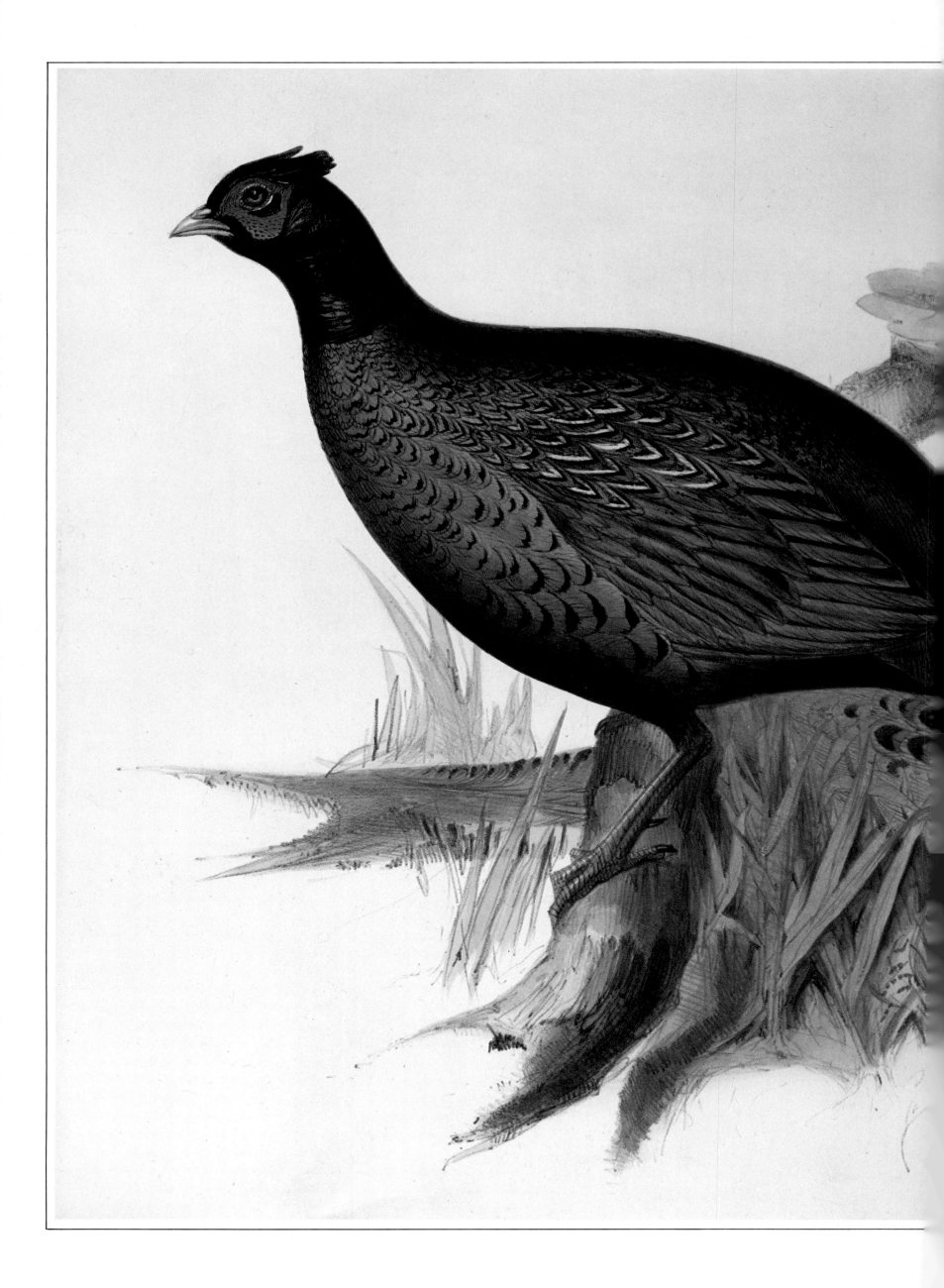

E. Lear. del.

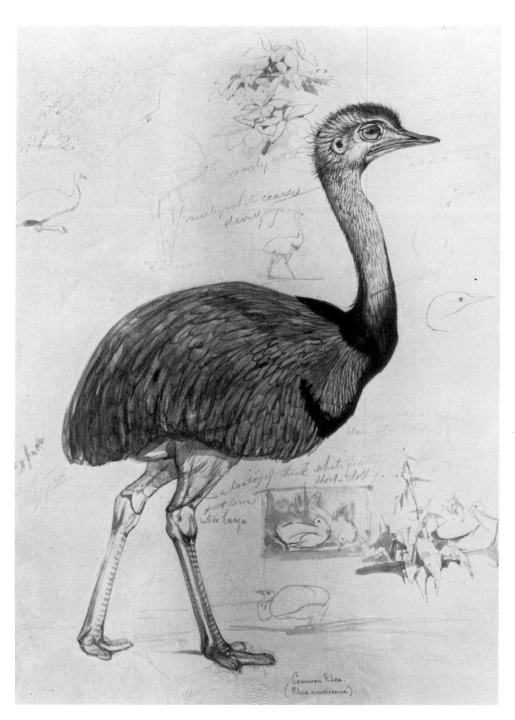

Preliminary study for the *Rhea americana*, filled with notes on textures and colours, and sketches of the bird in various poses.

For the next five years Lear lived at Knowsley Hall, except when his commitments to John Gould or other publishers called him to London, producing hundreds of drawings of animals and birds. Some of the best were reproduced in 1846 in *Gleanings from the Menagerie and Aviary at Knowsley Hall*, a volume now rare. The seventeen plates of mammals, birds and tortoises were lithographed by J. W. Moore, 'coloured by Mr Bayfield' (whose first name has never been traced) and printed by Hullmandel and Watson; the text and introduction were written by John Edward Gray. Lear did not supervise the production of the lithographs; by the time of their publication he was no longer working as a naturalist, and the delicacy of the original watercolours is often coarsened in translation, but the large birds, especially the emu and the cranes, retain their sense of personality.

Rhea americana, the original watercolour on which the plate in *Gleanings from the Menagerie and Aviary at Knowsley Hall* was based. In notes on the picture 'gleaned' from his diaries, the Earl of Derby complains that his difficulty in breeding this species is 'most provoking!'.

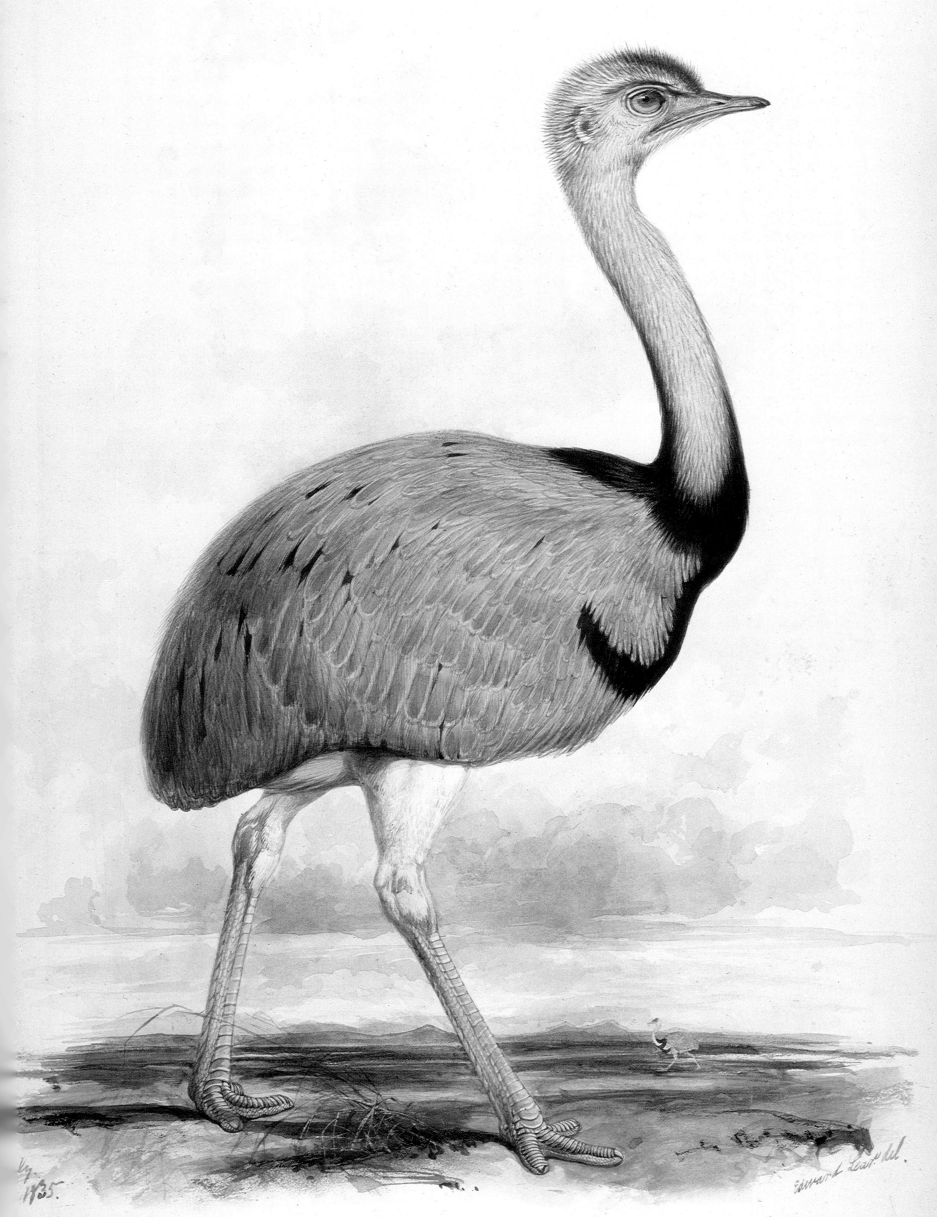

Rhea Americana (Linn) *East coast of South America.* *The Original of the plate in the 'Gleanings'.*

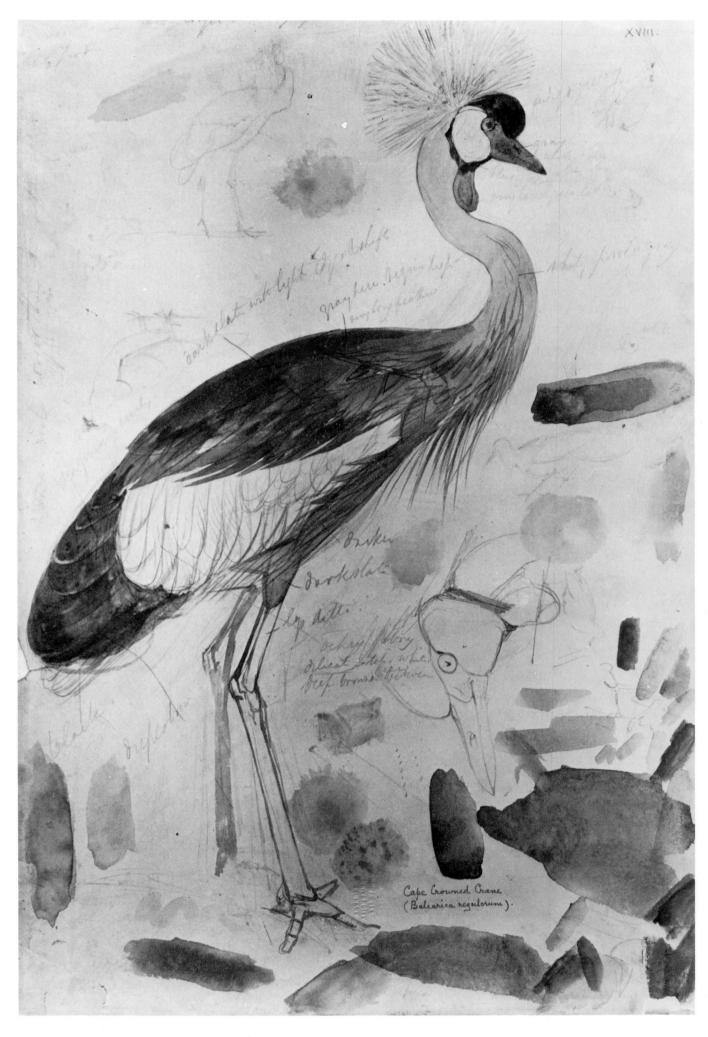

Preliminary study for the Crowned Crane (*Balearica regulorum*), a plate in
Gleanings from the Menagerie and Aviary at Knowsley Hall.

COMMON CRANE (*Grus cinerea*)
Volume IV *The Birds of Europe*

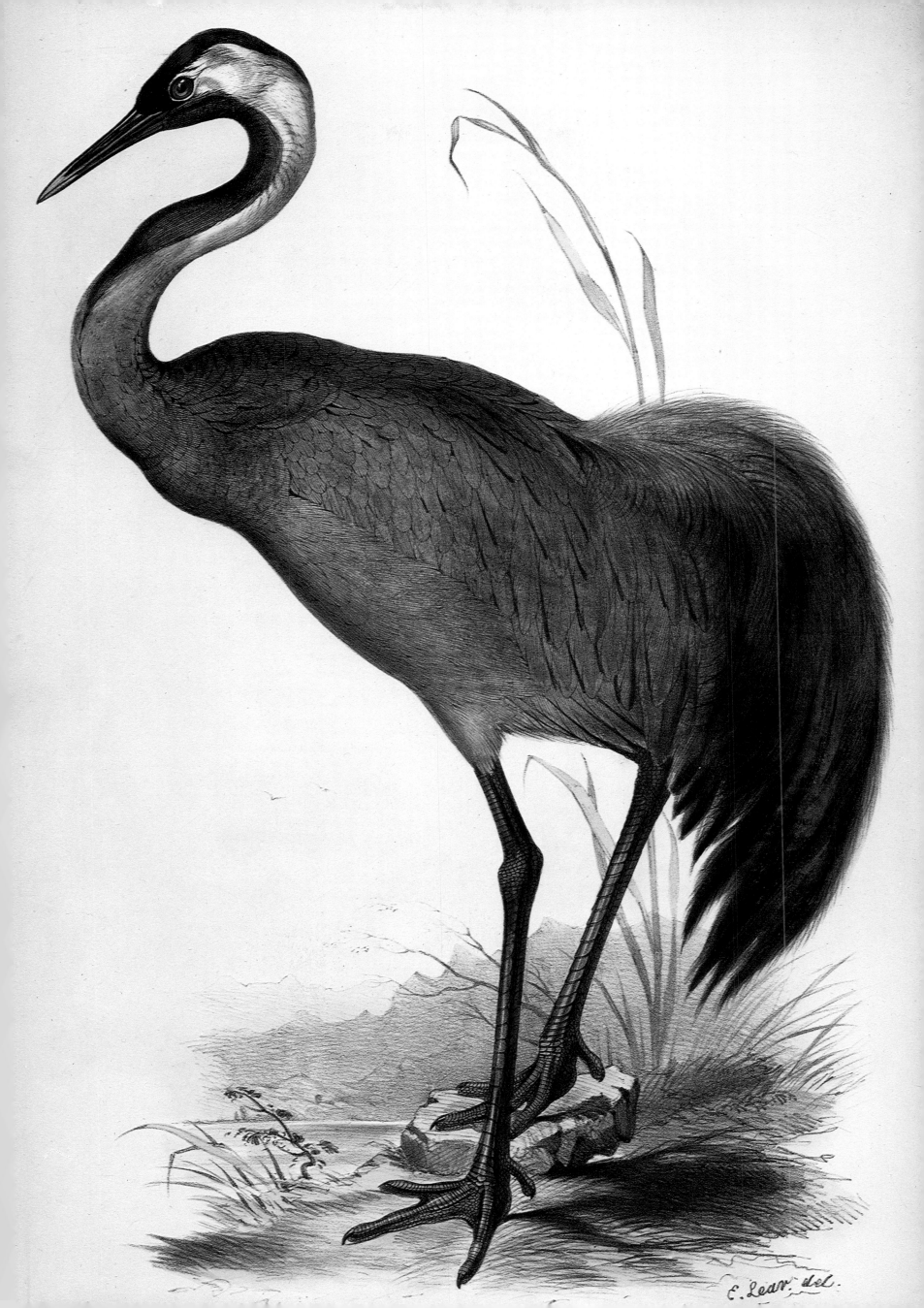

E. Lear del.

There was an Old Man with a beard,
Who said, 'It is just as I feared! —
Two Owls and a Hen,
Four Larks and a Wren,
Have all built their nests in my beard!'

The years Lear spent at Knowsley were some of the happiest of his life, certainly the most decisive. He had access to an extensive library and to a collection of Old Masters which included Rembrandt, Poussin and Velazquez. More important, he met '½ the fine people of the day', for the old Earl, Lord Stanley's father, was a hospitable man who often entertained eighty at dinner. Many of the acquaintances Lear made at Knowsley became his friends, travelling companions and faithful patrons, and it is a tribute to Lear's unusual talents that, arriving as an employee who lived and dined with the servants, he soon became a favourite guest. The Earl, noticing that the tribe of children, grandchildren, great-grandchildren, nephews and nieces all fled the noble apartments every evening after dinner to gather in the steward's quarters, discovered that they went there to be entertained by Lear with droll drawings and stories that he made up extempore. It may have been Lear's first experience of amusing small children with his inventions, and it is an interesting fact that he created his first Nonsense sketches by night while he was working by day in the menagerie, for his Nonsense and his nature studies have many affinities. Eventually the Earl, a discerning as well as a generous host, asked Lear to join the guests at dinner, and from that time he became an accepted member of the family circle. Lear had few social graces, was awkward in appearance, self-conscious and shy, and never showed any capacity for flattery. But he seems to have had an innate capacity for friendship, a great desire to please and a gentle charm that won the affection and trust of both children and adults. Perhaps more important than his zoological studies at Knowsley were the flowering of these two gifts – the gift of unforced intimacy and the gift of Nonsense.

In the summer of 1835 Lear visited the Wicklow Mountains in Ireland with Arthur Stanley, a cousin of the Earl and later Dean of Westminster; in 1836 he hiked in the Lake District. These sketching tours revived Lear's interest in landscape painting and may have encouraged him to give up the financially unremunerative and painstaking work of bird illustration. There were other inducements as well, for Lear longed for independence and the freedom to travel, and his health was failing. His eyesight was

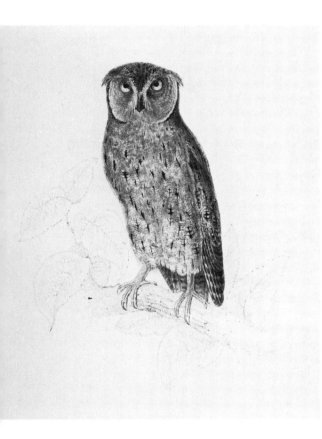

Ephialtes, a watercolour from Knowsley Hall, signed and dated 1831.

becoming too weak for the minutiae of animal studies, and the northern climate had aggravated his bronchitis and asthma. From Knowsley he wrote to Gould in 1836, 'Hail, Snow, Frost & Desolation . . . I have such a bad cold that I am half blind[and] my eyes are so sadly worse that no bird under an ostrich shall I soon be able to see to do.' He is enthusiastic about his tour, however, adding, 'how *enormously* I have enjoyed the whole Autumn'.

In 1834 Lear had enrolled at Sass's School of Art in Bloomsbury where students prepared for the entrance examination to the Royal Academy Schools, but the lack of finances necessary for the ten-year course had probably discouraged him from continuing. With help from the Earl of Derby and his nephew, Robert Hornby, Lear set out for Rome in the summer of 1837; except for one long stay in England between 1849 and 1853 and many shorter visits, he spent the rest of his life abroad, embarking enthusiastically on his new career as a landscape painter. At first he was homesick, complaining to the Earl on his arrival, 'It is all very beautiful & interesting & wonderful here, but – it is not England!' Later he wrote to Gould:

I am very glad I took to Landscape – it suits my taste so exactly & though I am but a mere beginner as yet – still do I hope by study & staying here to make a decent picture before I die. No early education in art – late attention. & bad eyes – are all against me – but renewed health & the assistance of more kind friends than mortal ever had I hope will prove the heaviest side of the balance.

In Rome Lear found a large colony of artists of all nationalities as well as many of the acquaintances he had made at Knowsley. 'Half the English peerage is here,' he wrote to his sister. 'Dinner and balls abound.' He held exhibitions of his work, first in Rome, then in Corfu, Nice, San Remo, wherever his wanderings took him. He published journals describing expeditions to Greece and Albania, southern Italy and Corsica, and wrote several others describing his

'I resolved to examine these mysterious white stones forthwith, when, lo! on my near approach, one and all put forth legs, long necks and great wings, and "stood confessed" so many great pelicans, which, with croakings expressive of great disgust at such ill-timed interruptions, rose up into the air in a body of five or six hundred, and soared slowly away to the cliffs north of the gulf.'

Avlóna, from *Journals of a Landscape Painter in Greece and Albania, &c.*, 1851.

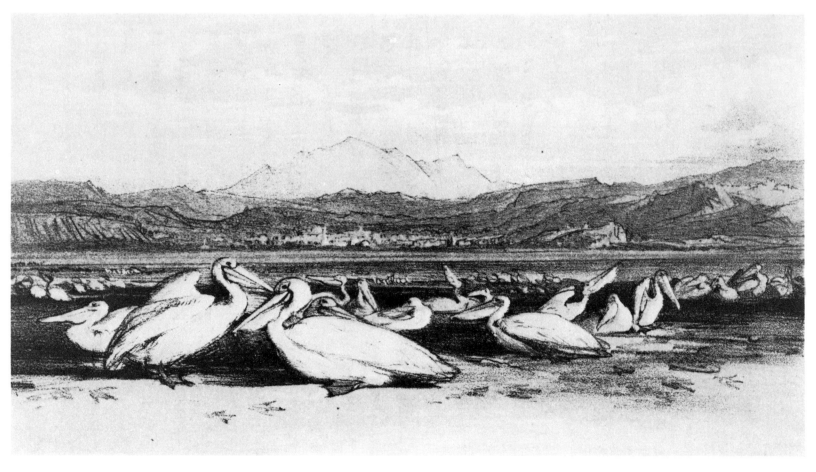

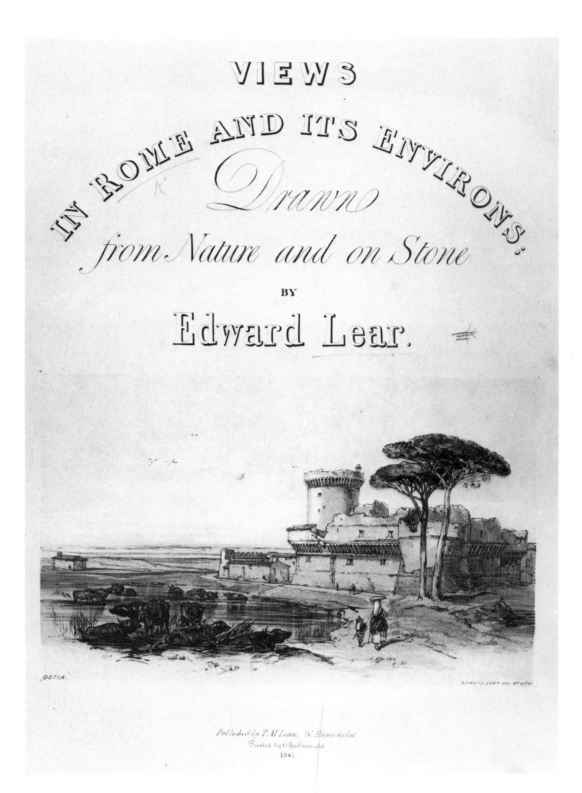

VIEWS IN ROME AND IT'S ENVIRONS.
Drawn from Nature and on Stone
BY
Edward Lear.

OSTIA

Published by T. M'Lean, 26 Haymarket
Printed by C.Hullmandel
1841

Lear published his first volume of topographical views in 1841. The landscape vignette on the title page betrays a taste for picturesque vistas and the Italian idylls of Claude and the young Turner.

adventures in Crete, Malta, Sicily, Mount Athos, Egypt and India. For a man of infirm health and precarious finances, who was terrified of horses and boats, irritated by physical discomfort and driven to distraction by noise, Lear was an intrepid and tireless traveller. He did not stick to the well-beaten paths of other English tourists, but explored the mountains of Albania and the deserts of Arabia, often travelling by foot into regions that were wild, dangerous and still comparatively unknown. In Albania, where painting was disapproved of by the ruling Turks, Lear was cursed as a blasphemer and pelted with stones; he took to wearing a fez and continued to draw, under the protection of a guard armed with a whip. In Petra he was attacked by Arab tribesmen who threatened his life and rifled his pockets of everything they contained 'from clothes and pen knives to handkerchiefs and hard-boiled eggs'. In Sicily he climbed Mount Etna which he reported 'nearly perpendicular and made of fine ash & sulphur into which you plunge to your knees at every step'. At Thebes he caught malaria and had

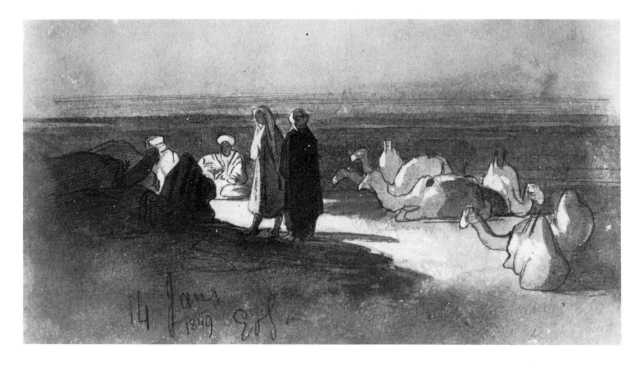

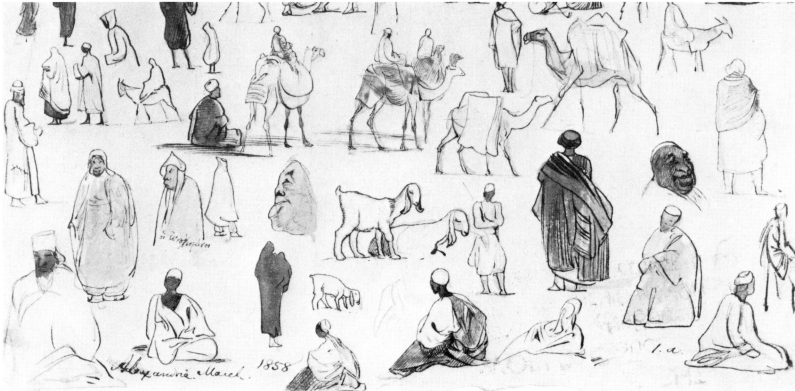

Top A night scene from Lear's first Egyptian tour, dated 14 January 1849.

Above Sketches from the market-place, Alexandria, March 1858.

to be transported back to Athens 'by 4 horses on an Indiarubber bed'. And at the age of sixty he went to India, travelling by train, elephant, horseback, carriages, carts and boats, suffering from the heat, failing health and frequent epileptic attacks; yet he managed to complete over fifteen hundred drawings and nine small sketch books and to keep a minutely-detailed diary.

In his Corsican journal Lear writes of 'that necessity which the wandering painter whose life's occupation is travelling for pictorial or topographic purposes – is sure to find continually arising, that of seeing some new place or of adding fresh landscape to both mind and portfolio'. Certainly Lear's pictures and journals required travel, but his need for constant movement sprang from a restless melancholy and a morbid conviction that he was unsuited by nature to marry and to have a home. He chose exile. Like the creatures in his Nonsense he is forever setting sail, sometimes to see the world, sometimes because he is 'not fit to come to court', often out of simple ennui, and always for the exhilaration of the journey

itself. Travel was tonic and relief, and he was constantly planning some new excursion. Merely the mention of foreign names was a kind of intoxication. Dreaming of Egypt, he writes,

I am quite crazy about Memphis & On & Isis and crocodiles & opthalmia & nubians – and simoons & sorcerers, & Sphingidae . . . I have a strong wish also to see Syria, & Asia Minor & all sorts of grisogonous places – but – who can tell.

He adds wistfully, 'Yet this is clear: – the days of possible Lotus-eating are diminishing.'

Lear never resumed his animal art systematically once he had left England. His major work was all completed by the time he was twenty-five and in 1862 he wrote to the Linnean Society asking that his name be removed from the list of Associates; by then his ornithological career may have seemed inconsistent with his high artistic aspirations. His interest in zoology and botany continued undiminished, however, and until the thirteenth Earl's death in

From an alphabet drawn in 1855 for Cecelia Lushington, the daughter of a close friend.

Lucknow, India. A watercolour dated 8 December 1873.

An artistic expedition in India. Lear directs; Giorgio carries the portfolio; a servant holds the sunshade. From a letter written in October 1875.

1851 he sent him detailed reports of the birds, animals and plants that he encountered on his travels. On his visits to England he always returned to the Zoo, once recording that he 'drew a lot of Vulchers'. He still took pride in his early accomplishments, long forgotten by all but his scientific colleagues. Thirty years after their publication he offered to send to Emily Tennyson illustrations of a 'blue & a red Maccaw with long tails and refulgent features ... these parrots being drawn & lithographed by myself, and by now scarce & out of print, are in a way valliable, and may be hung on your walls without any infradiggiousness'.

Lear also continued to write to John Gould, at one time requesting some stuffed birds to decorate his room. Lord Derby had already sent him 'two dozen or more little birds' and Lear asks for some further specimens, 'something that will look pretty – blue or green or red or white or yellow' to stand in belljars on his library table. From Rome he writes equivocally to Gould, 'I often think of you when I see the large kites and falcons which are so numerous in the mountains where I have been residing.' Describing the birds of Italy, bright yellow orioles in the chestnut groves of Ficenza, rollers in the valleys of Galara, bee-eaters about Ostia and eagles in the Apennines, he confesses, 'I often think of my Natural Historical days,' adding, 'No end of big bats here in the evening! & such lots of owls! You had better come; – Rome is worth seeing.'

Lear's 'Natural Historical' knowledge also enlivens his journals and letters. A trained observer with a highly developed eye and ear, he remarks with a fine particularity on the number of birds seen, their species and colouring. In Egypt he notes '4 black storks – one legged: apart. – 8 pelicans – careless foolish. 17 small ducks, cohesive. 23 herons – watchful variously posed: & 2 or 3 flocks of lovely ivory ibis'. In Italy he observes 'a mimosa, which small as it is, has the virtue and interest that it is full of birds, namely: 1 roller, 6 bee-eaters, 23 turtledoves and 17 Alexandrian parrots'. Travelling up the Nile he counts 'geese, pelicans, plovers, eagles, hawkes, cranes, herons, hoopoes, doves, pigeons [and] king fishers'. He is also alert to the sounds of different species and notes 'hosts of mynahs musicalizing in the bamboos', 'the kite's shrill tremulous fifing and the parrot's converse – familiar'. He is much cheered by avian society, writing in Athens that 'owls, the bird of Minerva, are extremely common, & come & sit very near me when I draw', and in India that 'the most beautiful plovers and kingfishers hop just before my feet!'

Some of the most lyrical and evocative passages in the journals are those describing birds; Lear's accounts of landscapes are never so precise and seldom so enthralled. Near Salonika he sees

varieties of zoology attracting observation on all sides. Countless kestrels hovering in the air, or rocking on tall thistles, hoopoes, rollers, myriads of jackdaws, great broad-winged falcons soaring above, and beautiful gray headed owls sitting composedly close to the roadside as we passed. ... The small black-and-white vulture was there too, and now and then a graceful milk-white egret, slowly stalking in searchful meditation.

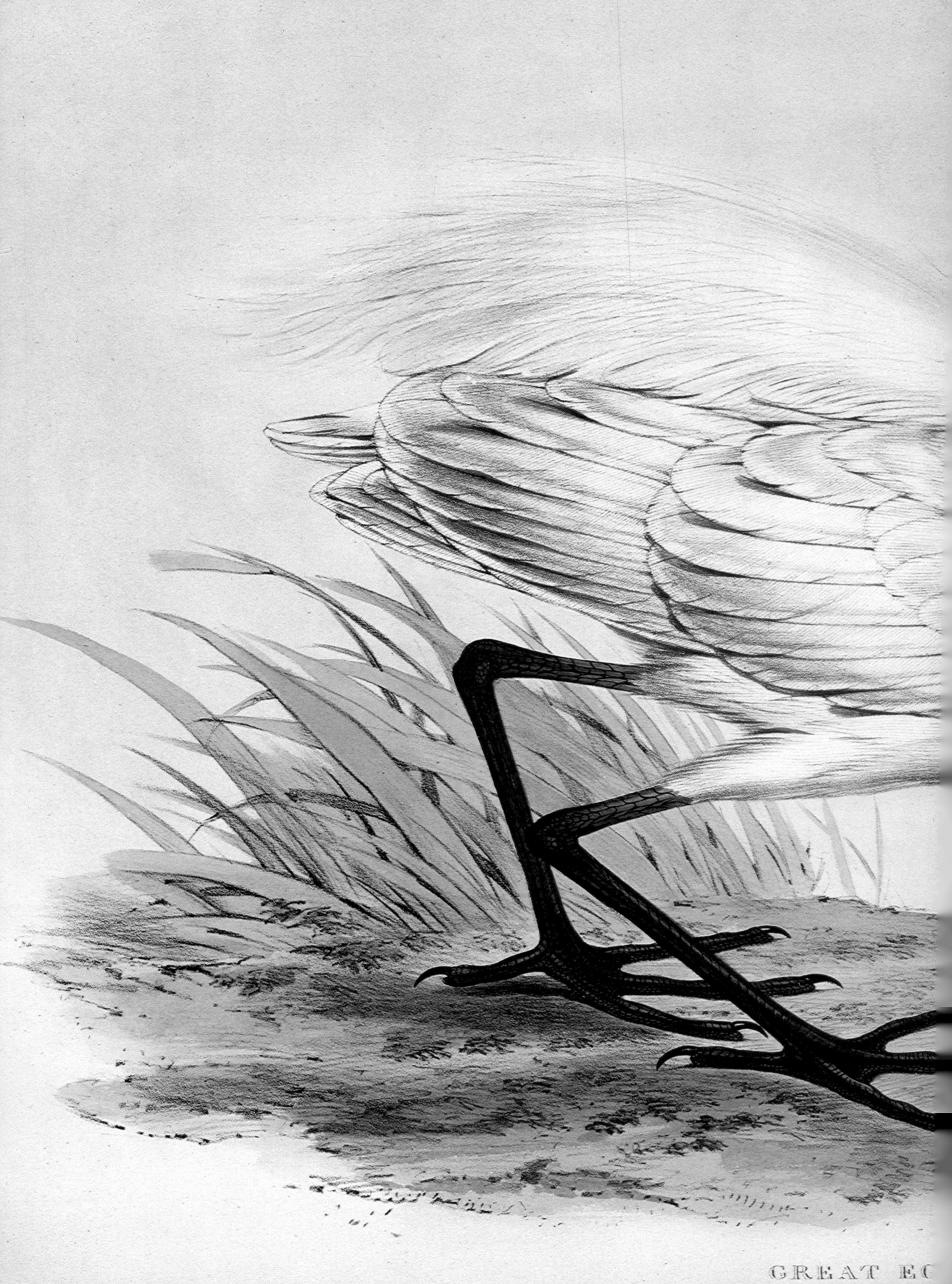

GREAT EC
Ardea alba.

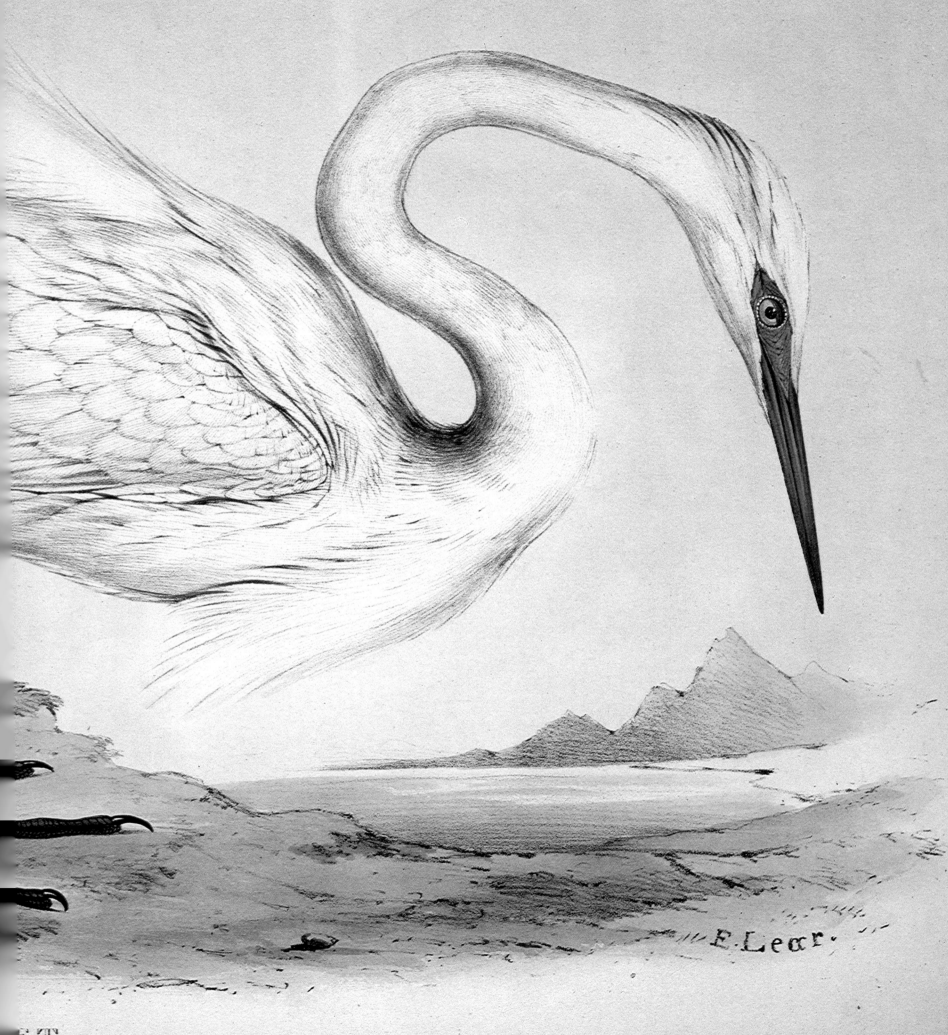

E.Lear.

In India he witnesses 'a world of Ornithology' and near Bharatpur 'a natural aviary':

> Peacocks and turtles here abound on all the roofs and walls; whoever dreamed of hearing so many all at once? Not to speak of tinpot-mending barbets. . . . Above us was a great tree full of apes and vampire bats and farther on, as the sun went down, other trees became loaded with peacocks and white egrets. . . . I never saw anything half so lovely and cannot think how I shall go away tomorrow!

Many of the more curious incidents in the journals concern 'ornithological novelties hitherto seen in the Zoological Gardens or at Knowsley'. At Frigento, in the Kingdom of Naples, he happens across a vast 'ornithological necropolis' by the side of a bubbling sulphurous lake. At Avlóna in northern Greece masses of large white stones arranged in regular rows 'stand confessed', on closer inspection, to be 'so many great pelicans which, with croakings expressive of great disgust . . . rose up into the air in a body of five or six hundred and soared slowly away to the cliffs north of the gulf'.

Lear's intimate knowledge of zoology enriched his appreciation of the vicissitudes of travel. At a Calabrian banquet he is somewhat dismayed by 'relays of the most surprising birds: among which my former ornithological studies caused me to recognize a few corvine mandibles whose appearance was not altogether in accordance with the culinary arrangements of polite society'. In India he complains that 'while in the bathroom the nearness of jackals is rather oppressive', and one evening in Thessaly he is entertained by the kicking and shrieking of several storks and an egret who have fallen through the roof, and 'four very wet jackdaws . . . [who] came down the chimney and hopped over me and about the room till dawn.'

Lear's training as a natural historian proved of use as well in his later career as a 'Topographical Landscape Painter'. Lear's own designation is revealing, for, though he loved dramatic and associative subjects, he considered himself a recorder rather than an interpreter of scenery, and as a naturalist draughtsman he excelled in the delineation of landscape in sweeping expressive lines. The scrupulous descriptive vision that had distinguished his illustrations of birds and animals, and the rapid calligraphic execution he had developed in capturing the essence of their form and movements, served him well in his swift transcription of picturesque vistas. Hubert Congreve, who accompanied him on several sketching expeditions, remembered that Lear would 'gaze for several minutes . . . through a monocular glass he always carried; then, laying down the glass, and adjusting his spectacles, he would put on paper the view before us, mountain range, villages and foreground, with a rapidity and accuracy that inspired me with awestruck admiration'. Lear's recording of botanical and geographical forms is always methodical (so literal were his views of Greece that they were once used by a professor of Classics to illustrate his lectures on the Persian Wars) and he covered his sketches with copious notes as to time, place, light, colour and texture, as well as whimsical reminders in his unorthodox spelling of 'rox', 'hawx', 'lams', 'grabble', 'Time and Assfiddle' and 'flox of gotes'. Later he 'penned out' the drawings in ink, sometimes adding

The aged & obese Landscape=
=painter will rejoice to come
to H. Excellency tomorrow. –
He hopes EB RAADC* will go
to Athens next Monday weak

Lear in an avian attitude. The initials stand for Evelyn Baring, Royal Artillery Aide-de-Camp.

colour washes. The sketches were used as personal memoranda, models for more formal drawings, lithographs or paintings; but their spontaneity and enthusiasm makes them more appealing than his finished works, and today they are much prized.

Lear's formal compositions, so different from his 'topographies', reveal a taste for the sublime and classical, for landscape observed through the eyes of a student of painting rather than a student of nature. In his journal he mentions 'a perfectly Poussinesque palazzo'; in Calabria he discovers 'Claude and Salvator Rosa at every step'. And it was her admiration for the traditional classical views in Lear's *Illustrated Excursions in Italy* that prompted Queen Victoria to summon Lear to her summer home at Osborne for drawing lessons.

Lear himself was convinced that he would never progress without conventional training 'unless as a painter of bees, black beetles and butterflies', and in 1849 he used the proceeds of a small legacy to enroll as a student at the Royal Academy, drawing for two years from plaster casts of antique models. He became a friend of several Pre-Raphaelite painters, including Thomas Seddon, Augustus Egg and Robert Martineau, whose commitment to descriptive detail and close observation recalled his early training in natural history. In 1852 he came under the powerful influence of William Holman Hunt. Lear accepted the younger man as 'the leader of the Pre-Raphaelites, let Mr R say as he may' and as his artistic mentor, referring to him as 'Pa', 'Daddy' or 'Beloved Parent'. He respectfully transcribed answers to his questions on the techniques of oil painting in 'Ye Booke of Hunt'. When Hunt protested that there was no need for Lear to return to Sicily to finish his painting of *The Quarries of Syracuse* when all the necessary ingredients could be found in England, Lear acquiesced. Together with Hunt, William Michael Rossetti and, for a time, John Everett Millais, he rented Clive Vale Farm near Hastings where, Hunt records, he found 'a spot with an abundance of fig branches rooted in the fissures of rocks with rooks in hundreds. Thus he obtained all the material for his picture. It was an impressive work.'

The Quarries of Syracuse, an enormous painting five feet in length, was exhibited at the Royal Academy the next summer, where it received the Art Union Prize and was bought by Henry Lygon, heir to the Earl of Beauchamp, for £250. Lear was elated by his success and wrote to Hunt, 'I am beginning to have perfect faith in the means employed and if the *Thermopylae* turns out right I am a P.R.B. forever.' But Lear's perseverance and strict adherence to Pre-Raphaelite principles did little to advance his art. His oils became increasingly literal and increasingly ambitious, his figures static and lifeless. He caught cold sketching a fig tree in the rain and so complete was his fall from grace that he once arrived for a day's work with a stuffed jackdaw which he wired to a tree in different positions. The inspiration with which he sketched both animals and landscape was never present in his huge exhibition pieces. Lear may

The painter and his public, from a letter of July 1860.

Overleaf SOLAN GANNET (*Sula bassana*)
Volume v *The Birds of Europe*
The adult bird is in front.

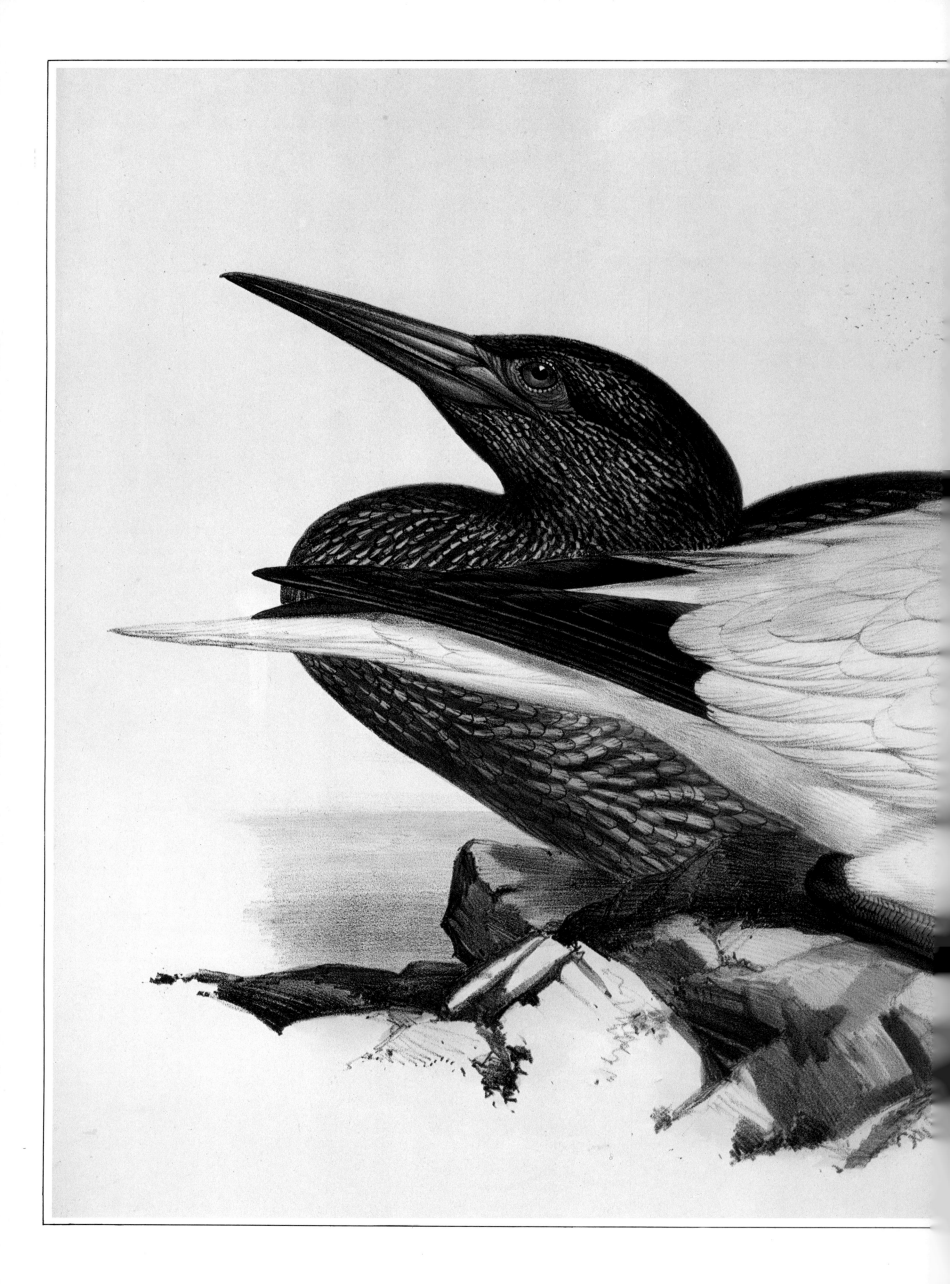

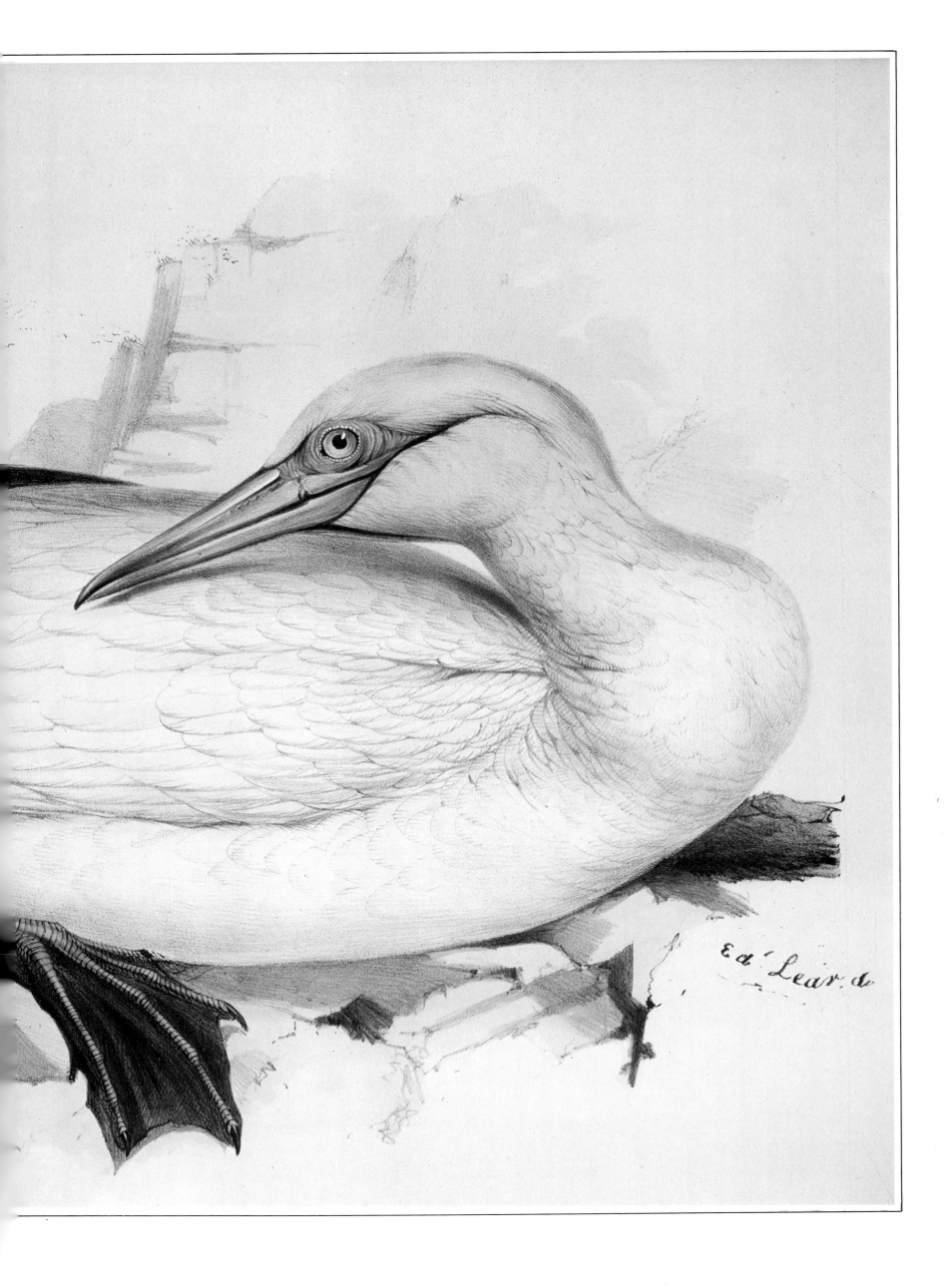

Ed.ª Lear. d.

have sensed a discrepancy between his true talents and his unfulfilled aspirations when he lamented, 'My topographical and varied interests as to different countries – my split-application by my musical-ornithological & other tastes – have all combined to bother and retard me'. And although he once advised a student 'to copy the works of the Almighty first and those of Turner next', he seems to have been altogether cut off from the artistic currents of his own time. Over the years his painting style changed little, except to become more rigid, although his watercolours and sketches retained their delicacy and precision.

Paradoxically, it is in his Nonsense rather than in his landscapes that Lear reveals himself most clearly as a trained naturalist. Like his contemporary, Lewis Carroll, his mind was 'concrete and fastidious', and as Carroll drew on the conundrums of logic, Lear drew on his scientific studies to create his Nonsense zoologies, botanies and geographies. Lear's self-contained world extends from the great Gromboolian plain and the Hills of the Chankly Bore across the Torrible Zone all the way to the Coast of Coromandel and the sunset isles of Boshen. ('The names of all these places you have probably heard of, and you have only not to look in your Geography books to find out all about them.') Creatures like the Quangle Wangle, the Pobble and the Cummerbund inhabit these regions, which produce a distinctive type of vegetation; those who travel in it may discover the Confidential Cucumber, the Crumpetty Tree and the Co-operative Cauliflower. *The Four Little Children Who Went Round the World* is a kind of travel journal with topographical descriptions as exact as any of Calabria or Corsica:

After a time they saw some land at a distance; and when they came to it, they found it was an island made of water quite surrounded by earth. Besides that, it was bordered by evanescent isthmuses with a great Gulf-Stream running about all over it, so that it was perfectly beautiful, and contained only a single tree, 503 feet high.

In the Nonsense Botanies Lear has added to the lore of Latin classifications and learned nomenclatures with his *Minspysia Deliciosa* and *Nasticreechia Krorluppia*, while in *The Pelican Chorus* there is a list of birds which echoes the inventory that he kept when he was travelling down the Nile:

> *Herons and Gulls, and Cormorants black,*
> *Cranes, and Flamingoes with scarlet back,*
> *Plovers and Storks, and Geese in clouds,*
> *Swans and Dilberry Ducks in crowds.*

Opposite, top COOT (*Fulica ater*)
Volume IV *The Birds of Europe*

Opposite, bottom DESMAREST'S CORMORANT (*Phalacrocorax desmarestii*)
Volume V *The Birds of Europe*

Overleaf GREAT AUK (*Alca impennis*)
Volume V *The Birds of Europe*
Although signed in the plate by Lear, an inscription at the lower margin of the lithograph (not visible here) reads 'Drawn from Nature and on Stone by J&E Gould'.

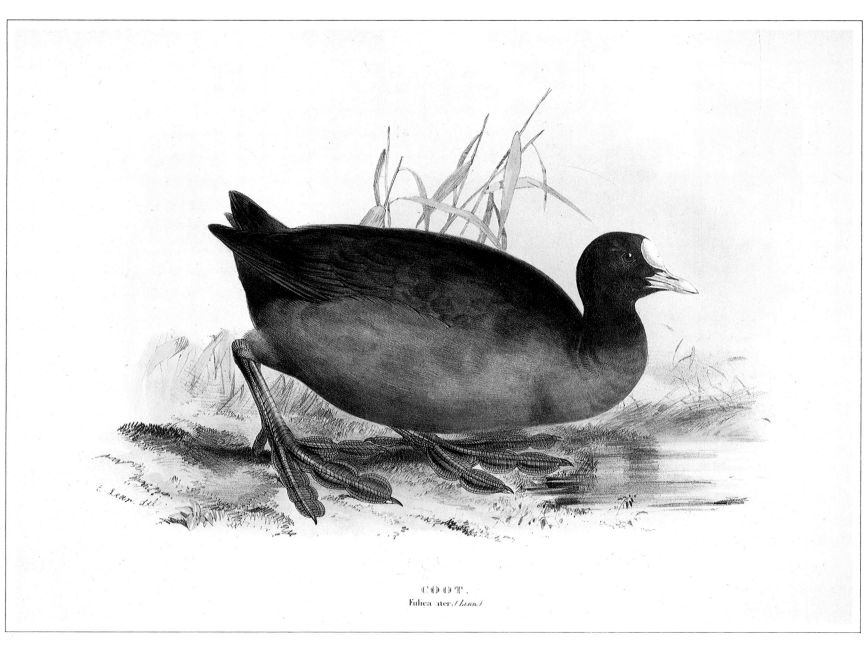

COOT.
Fulica ater.(Linn.)

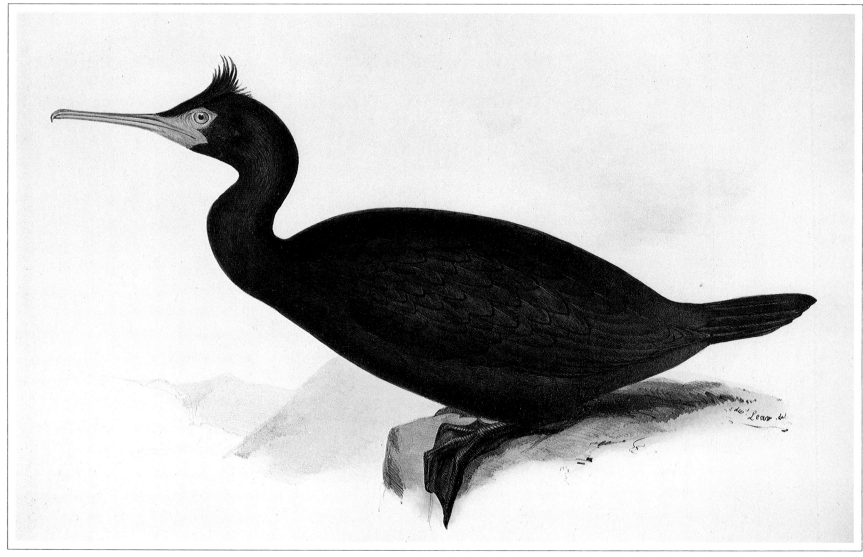

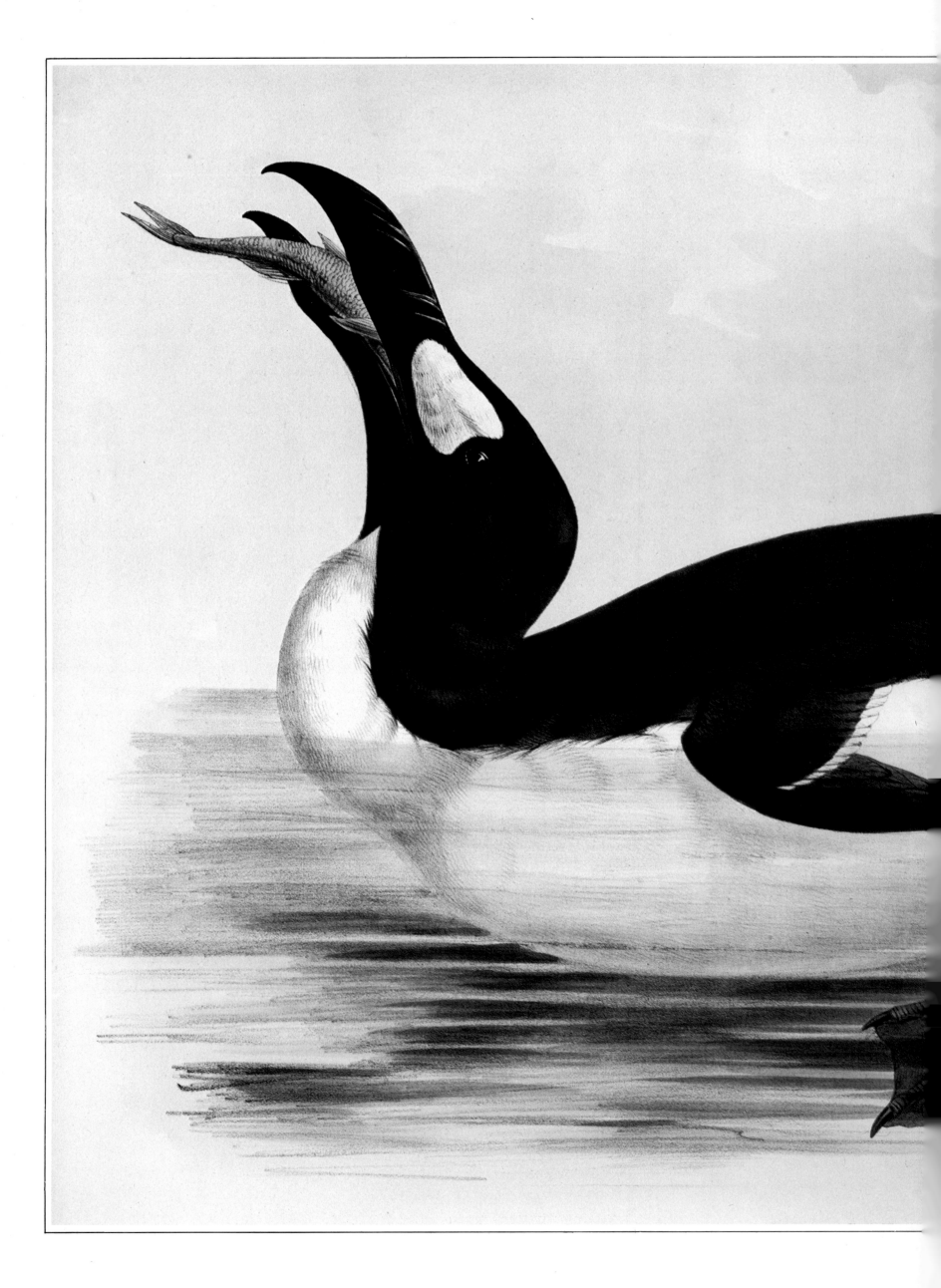

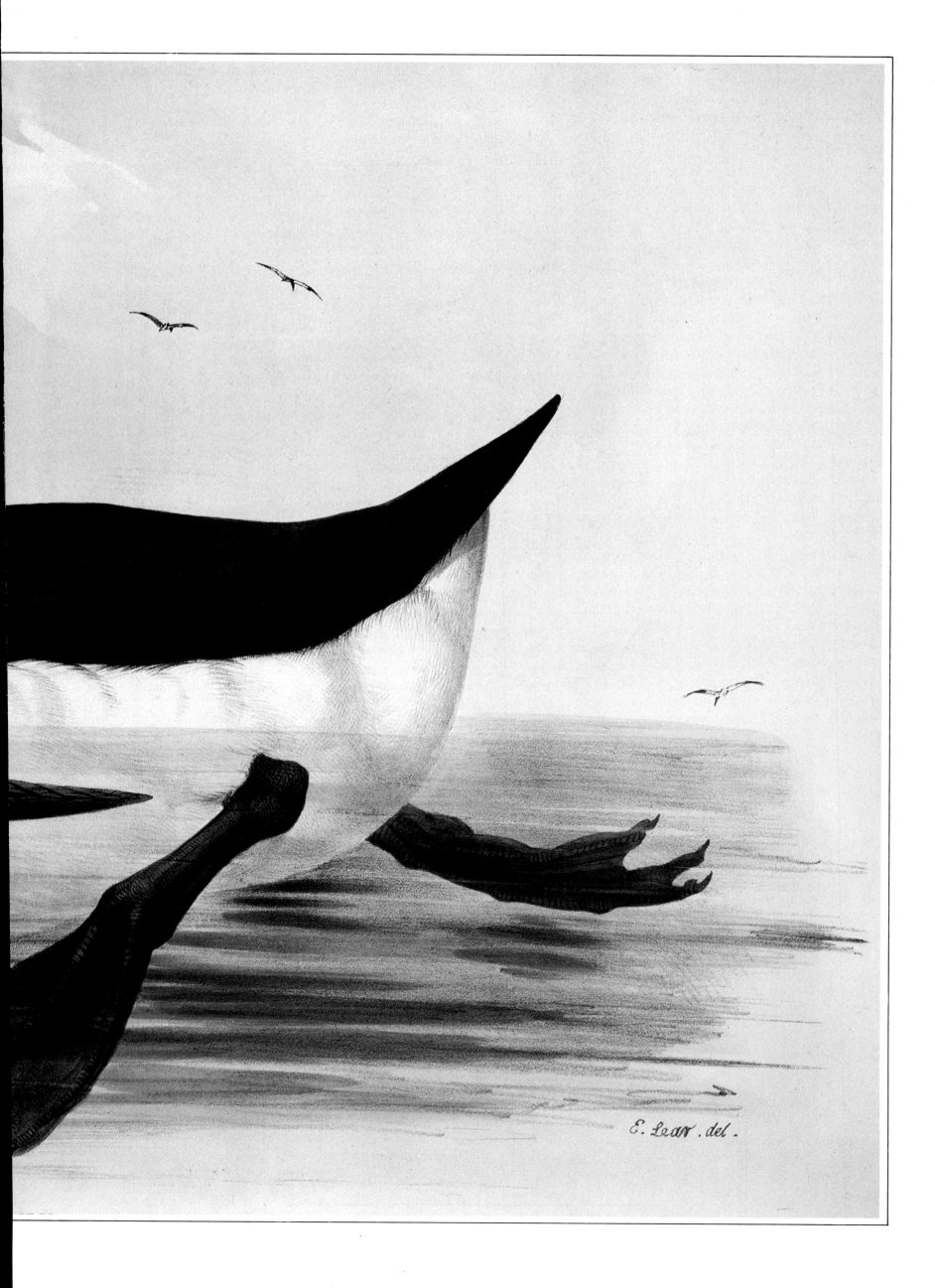

E. Lear. del.

There was an Old Man of Whitehaven, who danced a quadrille with a Raven;
But they said, "It's absurd to encourage this bird!"
So they smashed that Old Man of Whitehaven.

There was an Old Man who said, "Hush! I perceive a young bird in this bush!"
When they said, "Is it small?" he replied, "Not at all!
It is four times as big as the bush!"

There was a Young Lady whose bonnet came untied when the birds sate upon it;
But she said, "I don't care! all the birds in the air
Are welcome to sit on my bonnet!"

Three coloured woodblock prints from a rare edition of *The Book of Nonsense*
by the Brothers Dalziel.

Lear's Nonsense zoology is wide-ranging, but it was on his ornithological training that he drew most often. The birds in the Nonsense alphabets are small vignettes rather in the manner of Bewick. The characters in the limericks live in scenes of domestic fraternity with birds, dancing quadrilles with ravens, teaching owls to drink tea and ducklings to dance. People often look like birds and birds like people: The Old Man who said 'Hush! I perceive a young bird in this bush!' is confounded not merely by an oddity of ornithology, but by an encounter with a feathered *doppelgänger*; bird and man stare at each other with wide-eyed recognition. In *A Book of Nonsense and More Nonsense* abnormalities of appearance are usually avian in character: frock coats stand out stiffly like tails, arms are flung back like vestigial wings, noses resemble beaks, the unpopular man of Dumblane has the long spindly legs of a crane. At times the ambiguities of anatomy become even more pronounced as in the case of the Old Person of Nice whose associates were usually geese, the man of El Hums, who lived upon nothing but crumbs, and the Old Person of Crowle who lived in the nest of an owl. Many figures are happier in the air than on the ground, spending their days roosting on tree tops, perching on boughs and

There was an Old Person of Nice,
Whose associates were usually Geese.
They walked out together,
In all sorts of weather.
That affable Person of Nice!

There was an Old Man of El Hums,
Who lived upon nothing but Crumbs,
Which he picked off the ground,
With the other birds round,
In the roads and the lanes of El Hums.

There was an Old Man of Dumbree,
Who taught little Owls to drink Tea,
For he said, 'To eat mice
Is not proper or nice',
That amiable Man of Dumbree.

Self-caricature, from a letter
to Evelyn Baring, c. 1862.

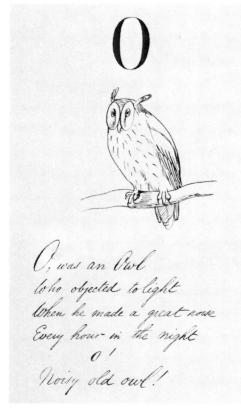
O, was an Owl
Who objected to light
When he made a great noise
Every hour in the night
O!
Noisy old owl!

From a nonsense alphabet in the
Houghton Library, Harvard
University.

dancing along branches. Lear draws himself in these avian attitudes, and often caricatures himself, perhaps because of his spectacles, as an owl, his favourite bird. 'Ah, que vos grandes lunettes vous donnent tout à fait l'air d'un gros hibou!' said a sagacious little girl he met in Corsica.

Lear's roles as a caricaturist and a naturalist are based upon qualities of mind that have singular affinities. The caricaturist depends upon the attentive and sensitive observation of human nature and upon a capacity for detachment. These talents Lear acquired in his earliest work, for his sense of being an outsider may well have made him unusually sympathetic to animals, especially to the large or eccentric ones, with whose ungainly appearance he could identify. The months Lear spent in the parrot house may have contributed to his later art in other ways as well. The facility he acquired for grasping the essence of feathered forms in swift fluent lines reappears in the incisive simplification of his limerick figures. Nowhere is this merging of ornithology and fancy more clearly shown than in the series of Nonsense birds that Lear invented to teach children colours. The forms and poses of these fantastic birds recall and parody the parrots of Lear's early book, but each has a distinctive personality and physiognomy of its own.

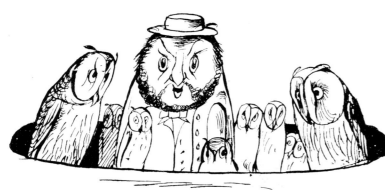

There was an Old Person of Crowle,
Who lived in the Nest of an Owl;
When they screamed in the nest,
He screamed out with the rest,
That depressing Old Person of Crowle.

The Owl looked up to the stars above,
And sang to a small guitar,
'O lovely Pussy! O Pussy, my love,
What a beautiful Pussy you are,
You are,
You are!
What a beautiful Pussy you are!'

SPECTACLED OWL (*Strix perspicillata*)
Watercolour, August 1836.

In a homesick letter written to the Earl of Derby two years later from Rome, Lear recalled this bird as his favourite.

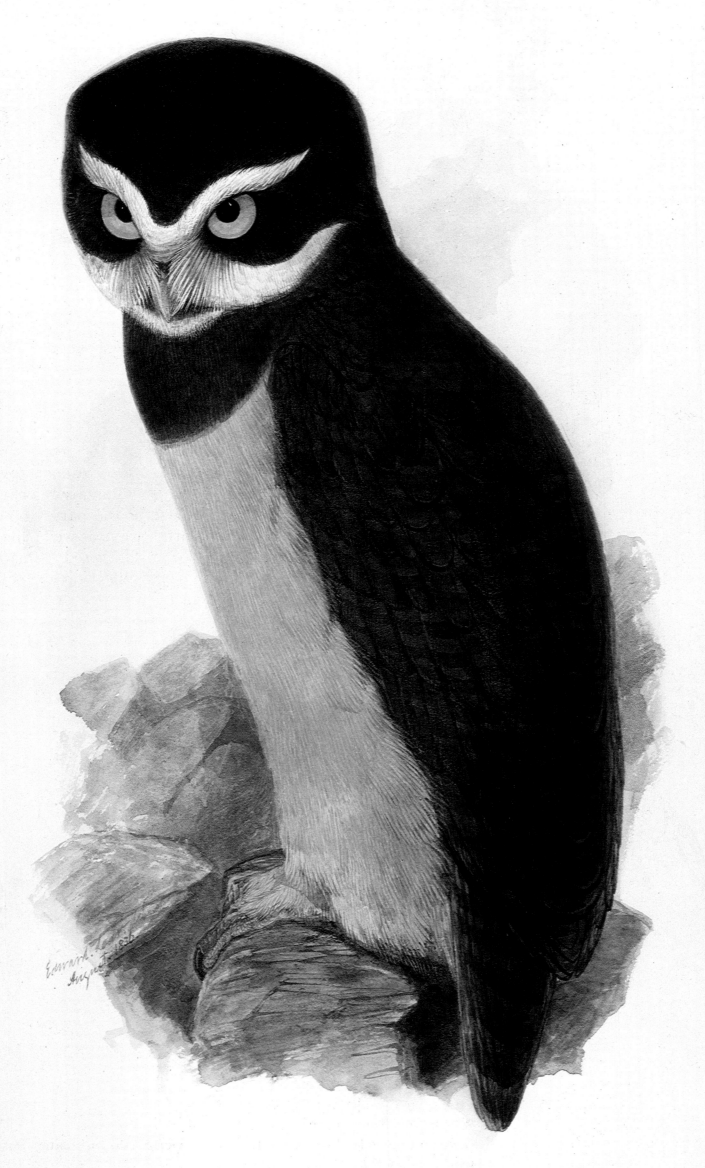

Spectacled Owl

Strix perspicillata

Two drawings from a series of sixteen made in northern Italy in 1880 for Charles Pirouet, a small boy staying at the same hotel as the artist.

The Earl of Cromer in his preface to *Lear's Coloured Bird Book for Children* commented:

The wonderful thing about Lear's nonsense birds is the way in which they are differentiated. Each bird has an entirely separate and distinct character. They are different species, not varieties of the same type. . . . Who can describe a 'Scroobious' or a 'Runcible' bird? Yet the man who does not at once grasp the fact that the outward appearance and special characteristics of these two birds must of necessity differ widely, will be wholly wanting in imagination.

One scholar has already written of this symbiotic relationship between the scientific and whimsical sides of Lear's character. Commenting on the unpublished illustrated lyric:

> *There was an old man of Bombay,*
> *Sate smoking one very hot day,*
> *When a bird (called a snipe) flew away with his pipe,*
> *Which grieved this old man of Bombay*

he conjectures:

The fact that Lear, a trained ornithologist, did not indicate the bird's coloration, suggests the sense of freedom from discipline he felt in making nonsense drawings – unless this specimen was an albino. . . . Precise identification of the snipe is difficult in the absence of coloration. The bird is probably the Pintail Snipe (*Capella stenura, Bonaparte*); less probably the Fantail Snipe, which is hard to distinguish from the Pintail. Both winter on the west coast of India. The Pintail is noted for its lightning zigzag flight which fits with the obvious surprise of the smoker. Various degrees of albinism have been noted in this species.

SNOWY OWL (*Strix nyctea*)
Volume I *The Birds of Europe*
The adult is on the right, a two-year-old bird on the left.

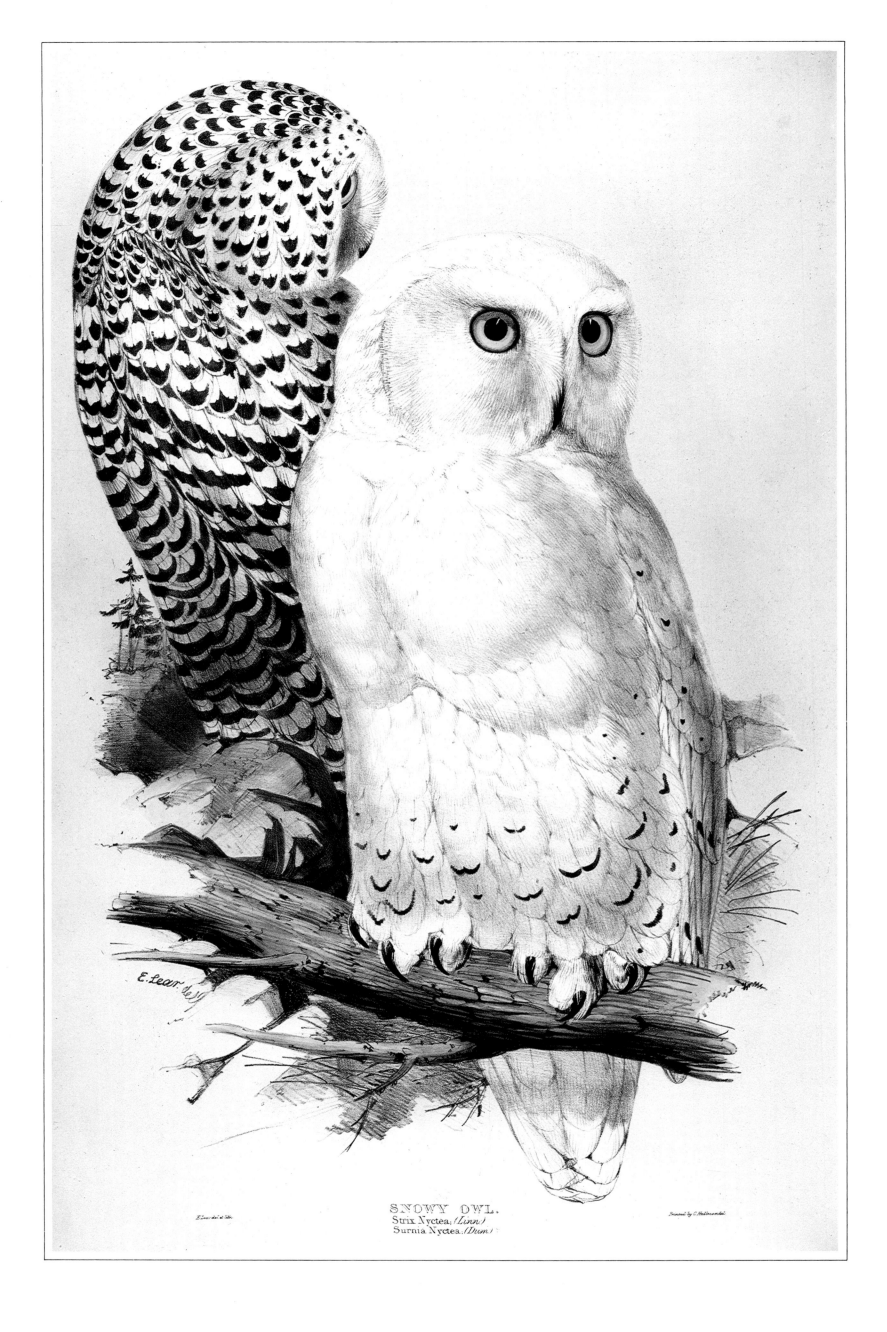

SNOWY OWL.
Strix Nyctea. (Linn.)
Surnia Nyctea. (Dum.)

E.Lear. del.

E.Lear del. et lith.

Printed by C.Hullmandel.

Such erudition is impressive, but perhaps slightly superfluous to
the appreciation of Lear's peculiarly eclectic talents. It may be
enough to note that as time passed the comic and fanciful side of
Lear's nature became increasingly separate from his professional
pursuits. But the methodical and imaginative aspects of his art
were united most successfully in his bird lithographs, the best of
which have the authority and idiosyncratic personality of his
Nonsense figures. And even later there were still happy instances, as
in the comic bird series he invented for the instruction and diversion
of children, when the naturalist and the Nonsense poet were one.

Lear spent his last years at his villa in San Remo, accompanied
nearly till the end by his faithful Suliot servant Giorgio Kokali and
his famous cat Foss. In declining health he remained, in his own
words, 'a very energetic and frisky old cove', painting steadily,
holding exhibitions, tending his garden and attempting to publish
his illustrations to Tennyson's poems. At first, he used details
drawn from his topographies as visual equivalents for the verse.

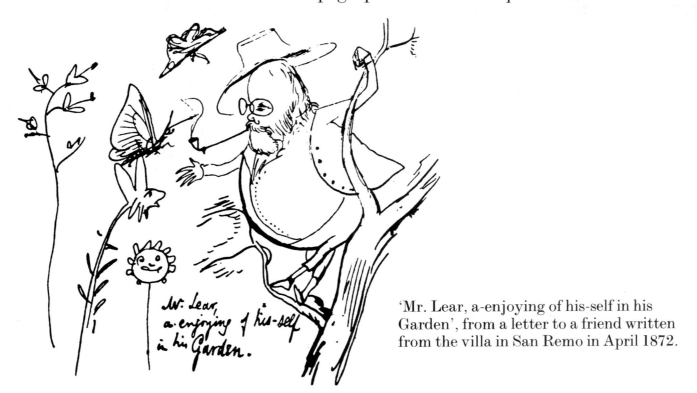

'Mr. Lear, a-enjoying of his-self in his
Garden', from a letter to a friend written
from the villa in San Remo in April 1872.

But as his eyesight failed, his style became, of necessity rather than by choice, increasingly impressionistic. When it no longer mattered, his art moved from description to discovery and the imagery of 'the vast and gloomy dark', a desolate inner landscape that was not the Laureate's but his own.

Age and blindness finally defeated him. Too ill to work, he succumbed to violent depression, his oldest, truest enemy. 'My own life seems to me more and more unsatisfactory and melancholy and dark,' he wrote. 'On the whole I do not know if I am living or dead at times.' His memory failed and his world became peopled with shadows. It was too late to escape to another country; his long years of wandering, his days of 'Lotus-eating', were ended. Once, in a mock trial, Lear had been condemned

> *To make large drawings nobody will buy –*
> *To paint oil pictures which will never dry –*
> *To write new books which nobody will read –*
> *To drink weak tea, on tough old pigs to feed –*
> *Till spring-time brings the birds and leaves and flowers,*
> *And time restores a world of happier hours.*

In the spring of 1887, on days when he was well enough to leave his bed, he sat on the terrace outside his villa. The garden was in full bloom and there were ten newly-hatched pigeons, 'a great diversion'. The birds and flowers which were among his first delights were his last.

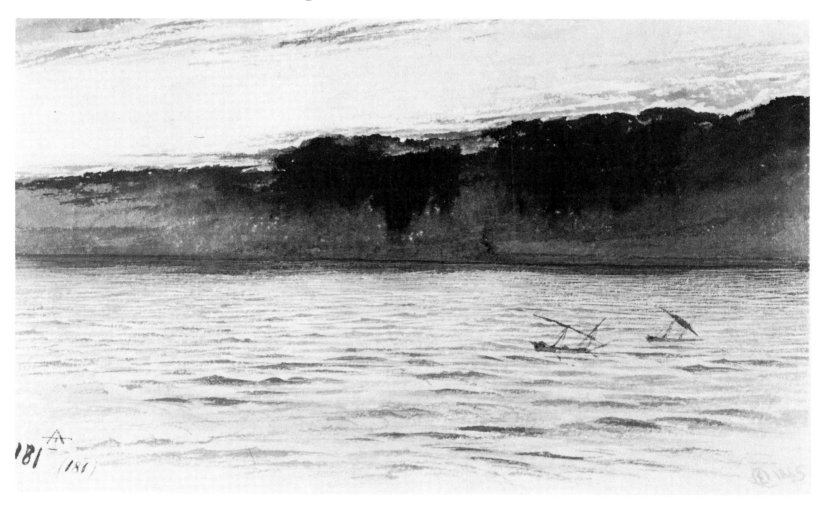

Coast of Travancore, India, 1885, pen and wash. One of the Tennyson series and intended to be an illustration to *In Memoriam*. Lear's last drawings are images of despair and turmoil, darkness gathering over ancient ruins, unassailable precipices, boats on a storm-tossed sea.

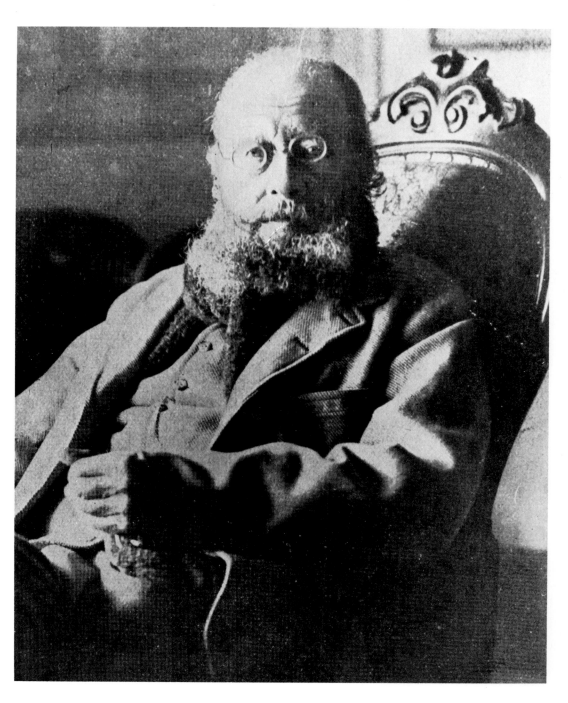

The last photograph taken of Lear, in 1887.

Edward Lear died quietly on 29 January 1888 attended by his physician and clergyman. His last words were an expression of gratitude to his friends for their goodness to him. Years before, in a letter to Chichester Fortescue, a companion in his youth and a confidant throughout his life, he had speculated on the possibility of a heaven. Perhaps he remembered the stately park at Knowsley where he had spent the finest days of his youth, or perhaps those felicitous foreign shores for which his Nonsense figures again and again set sail, when he voiced the hope that

in the next eggzi stens you and I and My lady may be able to sit for placid hours under a lotus tree a eating of ice creams and pelican pie, with our feet in a hazure coloured stream and with the birds and beasts of Paradise a sporting around us.

'. . . I think of marrying some domestic
henbird and then building a nest in one of
my own olive trees, where I should only
descend at remote intervals during the rest
of my life.'

From a letter to Lord Carlingford, written
on Christmas Day, 1871.

CHRONOLOGY

1812 Birth on 12 May at Bowman's Lodge, Highgate, London.

1823 First visits sister, Sarah Street, in Arundel, Sussex.

1828–32 Working in London. Contributes illustrations to zoological works. Publication of *Illustrations of the Family of Psittacidae, or Parrots.*

1832–7 Mainly at Knowsley, home of the Earl of Derby. Publication of John Gould's *A Monograph of the Ramphastidae, or Family of Toucans* and *The Birds of Europe.*

1837–48 Living in Rome with occasional visits to England and travels in southern Italy.

1841 Publication of *Views in Rome and its Environs.*

1846 Publication of *Illustrated Excursions in Italy.* Gives drawing lessons to Queen Victoria. Publication of *A Book of Nonsense* and *Gleanings from the Menagerie and Aviary at Knowsley Hall.*

1848–9 Travels in Greece, Albania, Ionian Islands, Egypt and Malta.

1849–53 Living in England. Enrols as a student at Royal Academy Schools.

1850 Begins exhibiting at Royal Academy.

1851 Publication of *Journals of a Landscape Painter in Greece and Albania, &c.*

1852 Meets Holman Hunt. Publication of *Journals of a Landscape Painter in Southern Calabria.*

1853 *The Quarries of Syracuse* awarded Art Union Prize at Royal Academy.

1855–8 Living in Corfu, with further travels in Greece and the Near East, including Jerusalem, Damascus and Petra.

1858–60 Mainly in Rome.

1859 *Temple of Apollo at Bassae* presented to the Fitzwilliam Museum.

1860–1 Mainly in England.

1861 Return to Corfu, which remains his home between expeditions until 1864. Third, enlarged edition of *A Book of Nonsense* published. Winter and spring in England. Death of sister, Ann Lear.

1863 Publication of *Views in the Seven Ionian Islands.*

1864 Leaves Corfu for Athens, visits Crete.

1865–7 Travels in Greece, Italy and Malta, extended visit to Egypt. Summers in England.

1867–70 Living in Cannes, with visit to Corsica in late spring 1868.

1870 Publication of *Journal of a Landscape Painter in Corsica.*

1871 Publication of *Nonsense Songs, Stories, Botany and Alphabets.* Moves into Villa Emily at San Remo, his home until 1881.

1872 Publication of *More Nonsense, Pictures, Rhymes, Botany* and *Tortoises, Terrapins and Turtles.*

1873 Enters last Royal Academy exhibition.

1873–4 Tour of India and Ceylon.

1877 Publication of *Laughable Lyrics.*

1880 Last visit to England.

1881 Moves out of Villa Emily and into Villa Tennyson, San Remo, his home until death. Summers spent at Monte Generoso and elsewhere above San Remo.

1883 Death of Giorgio Kokali, his manservant since 1856.

1887 Death of his cat Foss, aged seventeen.

1888 Death on 29 January.

BIBLIOGRAPHY

I Works by Edward Lear published in his lifetime

NATURAL HISTORY

Books by Lear

Illustrations of the Family of Psittacidae, or Parrots, pub. Rudolf Ackermann and Edward Lear (London, 1830–2)

Gleanings from the Menagerie and Aviary at Knowsley Hall, ed. John Edward Gray (privately printed, 1846)

Books to which Lear contributed

The Gardens and Menagerie of the Zoological Society Delineated, ed. Edward Taylor Bennett (London, 1831)

A Century of Birds from the Himalayan Mountains, John Gould (London, 1831)

Illustrations of British Ornithology, Sir William Jardine, Bart, and Prideaux John Selby, vols. III and IV (London, 1834)

A Monograph of the Ramphastidae, or Family of Toucans, John Gould (London, 1834)

The Transactions of the Zoological Society, vol. I (London, 1835)

A Monograph of the Testudinata, Thomas Bell, parts I–VIII (London, 1836)

A History of British Quadrupeds, including the Cetacea, Thomas Bell (London, 1837)

The Birds of Australia, John Gould, parts I and II (London, 1837)

The Birds of Europe, John Gould (London, 1832–7)

Icones Avium, John Gould (London, 1837)

A Monograph on the Anatidae, or Duck Tribe, Thomas Campbell Eyton (London, 1838)

A Monograph of the Trogonidae, or Family of Trogons, John Gould (London, 1838)

The Zoology of Captain Beechey's Voyage (London, 1839)

The Transactions of the Zoological Society, vol. II (London, 1841)

The Zoology of the Voyage of the HMS *Beagle*, ed. Charles Darwin (London, 1841)

The Naturalist's Library, ed. Sir William Jardine, Bart, vol. II Monkeys; vol. IV Felines; vol. IX Pigeons; vol. XVIII Parrots (London, 1843)

The Genera of Birds, George Robert Gray, vol. II (London, 1849)

Tortoises, Terrapins and Turtles, ed. John Edward Gray (London, 1872)

Illustrations of the Duck Tribe, Sir William Jardine, Bart (privately printed, n.d.)

NONSENSE

A Book of Nonsense, Derry Down Derry (Edward Lear) (Thomas McLean, London, 1846, 1855)

A Book of Nonsense, new and enlarged edition (Routledge, Warne & Routledge, London, 1861)

Nonsense Songs, Stories, Botany and Alphabets (Robert Bush, London, 1871)

More Nonsense, Pictures, Rhymes, Botany, &c. (Robert Bush, London, 1872)

Laughable Lyrics, A Fourth Book of Nonsense Poems, Songs, Botany, Music, &c. (Robert Bush, London, 1877)

TOPOGRAPHY AND TRAVEL

Views in Rome and its Environs (Thomas McLean, London, 1841)

Illustrated Excursions in Italy, first series (Thomas McLean, London, 1846)

Illustrated Excursions in Italy, vol. II (Thomas McLean, London, 1846)

Journals of a Landscape Painter in Greece and Albania, &c (Richard Bentley, London, 1851)

Journals of a Landscape Painter in Southern Calabria, &c (Richard Bentley, London, 1852)

Views in the Seven Ionian Islands (Edward Lear, London, 1863)

Journal of a Landscape Painter in Corsica (Robert Bush, London, 1870)

II Works by Edward Lear published posthumously

MISCELLANEOUS

Poems of Alfred, Lord Tennyson, illus. Edward Lear (Boussod, Valadon & Co., London, 1889)

Lear in Sicily, intro. Granville Proby (Duckworth, London, 1938)

NONSENSE

Nonsense Songs and Stories, intro. Sir Edward Strachey (Frederick Warne, London, 1894)

Queery Leary Nonsense, ed. Lady Strachey (Mills & Boon, London, 1911)

The Lear Coloured Bird Book for Children, foreword J. St Loe Strachey (Mills & Boon, London, 1912)

Facsimile of a Nonsense Alphabet drawn and written by Edward Lear (Frederick Warne, London, 1926)

The Lear Omnibus, ed. R. L. Mégroz (T. Nelson, London, 1938)

The Complete Nonsense of Edward Lear, ed. Holbrook Jackson (Faber & Faber, London, 1947)

A Nonsense Alphabet (H.M.S.O., London, 1952; Doubleday, New York)

Teapots and Quails and Other New Nonsenses, ed. Angus Davidson and Philip Hofer (John Murray, London, 1953; Dufour, Chester Springs, Pennsylvania)

ABC (Constable Young Books, London, 1965; McGraw-Hill, New York)

Lear in the Original, ed. Herman Liebert (Oxford University Press, London, 1975)

A Book of Bosh, ed. Brian Alderson (Penguin, Harmondsworth, Middlesex, 1975)

For Lovers of Birds, compiled by Vivien Noakes and Charles Lewsen (Collins, London, 1978)

For Lovers of Cats, compiled by Vivien Noakes and Charles Lewsen (Collins, London, 1978)

For Lovers of Flowers and Gardens, compiled by Vivien Noakes and Charles Lewsen (Collins, London, 1978)

For Lovers of Food, compiled by Vivien Noakes and Charles Lewsen (Collins, London, 1978)

LETTERS

Letters of Edward Lear, ed. Lady Strachey (T. Fisher Unwin, London, 1907)

Later Letters of Edward Lear, ed. Lady Strachey (T. Fisher Unwin, London, 1911)

TOPOGRAPHY AND TRAVEL

Edward Lear's Journals: A Selection, ed. H. Van Thal (Arthur Barker, London, 1952)

Edward Lear's Indian Journal, ed. Ray Murphy (Jarrolds, London, 1953)

Edward Lear In Southern Italy, intro. Peter Quennell (William Kimber, London, 1964)

Edward Lear in Greece (William Kimber, London, 1965)

Lear's Corfu, intro. Lawrence Durrell (Corfu Travel, Corfu, 1965)

Edward Lear in Corsica (William Kimber, London, 1966)

III **Works on Edward Lear**

BOOKS

Byrom, Thomas, *Nonsense and Wonder: The Poems and Cartoons of Edward Lear* (Dutton, New York, 1977)

Davidson, Angus, *Edward Lear: Landscape Painter and Nonsense Poet* (John Murray, London, 1938; Kennikat Press, Port Washington, NY)

Field, William B. Osgood, *Edward Lear on my Shelves* (privately printed, 1933)

Hofer, Philip, *Edward Lear as a Landscape Draughtsman* (Oxford University Press, London, 1968; Harvard University Press, Cambridge, Mass.)

Lehmann, John, *Edward Lear and His World* (Thames & Hudson, London, 1977; Scribner's, New York)

Noakes, Vivien, *Edward Lear: The Life of a Wanderer* (Collins, London, 1968; reprinted Fontana/Collins, 1979; Houghton Mifflin, New York)

Reade, Brian, *Edward Lear's Parrots* (Duckworth, London, 1949), reprinted as *An Essay on Edward Lear's Illustrations of the Family of Psittacidae, or Parrots* (Johnson Reprint Corp., New York, 1979)

Richardson, Joanna, *Edward Lear* (Longmans, Green, London, 1965; British Book Centre, Elmsford, N.Y.)

ARTICLES

Bury, Adrian, 'The Other Side of Edward Lear', *Antique Collector* (August, 1963)

Hofer, Philip, 'Edward Lear, one of the ablest topographical draughtsmen of his day', *Connoisseur* (January, 1967)

Lambourne, Maureen, 'Birds of a Feather. Edward Lear and Elizabeth Gould', *Country Life* (June, 1964)

Mathews, Gregory M., 'Dates of Issue of Lear's Illustr. Psittacidae', *Austral Avian Record*, vol. 1 no. 1 (1912)

Neve, Christopher, There was a Young Person of Edward Lear's Parrots', *Country Life* (April, 1972)

Reade, Brian, 'The Birds of Edward Lear', *Signature*, no. 4 (1947)

CATALOGUES

Edward Lear 1812–1888 (Arts Council, Great Britain, 1958)

Drawings by Edward Lear (Henry E. Huntington Library and Art Gallery, San Marino, California, 1962)

Edward Lear, Drawings from a Greek Tour (Graves Art Gallery, Sheffield, 1964)

Edward Lear. Painter, Poet and Draughtsman (Worcester Art Museum, Worcester, Mass., 1968)

Edward Lear 1812–1888 (Gooden and Fox, London, 1968)

Edward Lear in Greece (International Exhibitions Foundation, Washington, D.C., 1971)

Edward Lear and Knowsley. An Exhibition of Watercolours Belonging to the Earl of Derby (Walker Art Gallery, Liverpool, 1975)

The Rediscovery of Greece. Travellers and Romantics in the 19th Century (Fine Art Society, London, 1979)

IV **Bird Books and Ornithology**

Anker, Jean, *Bird Books and Bird Art. An outline of the literary history and iconography of descriptive ornithology* (Levin and Munksgaard, Copenhagen, 1938)

Balis, Jan, *Merveilleux Plumages. Dix Siècles de Livres d'Oiseaux* (Société Royale de Zoologie, Anvers, 1968)

Buchanan, Handasyde, *Nature Into Art: A Treasury of Great Natural History Books* (Weidenfeld & Nicolson, London, 1979)

Dance, S. Peter, *The Art of Natural History* (Country Life, London, 1978)

Grassé, P. P., *Larousse Animal Portraits* (Hamlyn, London, 1977)

Irwin, Raymond, *British Bird Books: An Index to British Ornithology, 1481–1948* (Grafton & Co., London, 1951)

Jackson, Christine, *Bird Illustrators. Some Artists in Early Lithography* (Witherby, London, 1975)

Jackson, Christine, *Wood Engravings of Birds* (Witherby, London, 1978)

Jenkins, Alan C., *The Naturalists* (Hamish Hamilton, London, 1978)

Knight, David, *Zoological Illustration* (Archon Books, Hamden, Conn., 1977)

Lewis, Frank, *A Dictionary of British Bird Painters* (F. Lewis, The Tithe House, Leigh-on-Sea, 1974)

Lysaght, A.M., *The Book of Birds. Five Centuries of Bird Illustration* (Phaidon, London, 1975)

Mullens, W.H. & Swann, H. Kirke, *A Bibliography of British Ornithology* (Macmillan, London, 1917)

Nissen, Claus, *Die Illustrierten Vogelbücher. Geschichte und Bibliographie* (Hiersmann Verlag, Stuttgart, 1953)

 Schöne Vogelbücher (Herbert Reichner Verlag, Vienna, 1936)

Ronsil, René, *L'Art Français dans le Livre d'Oiseaux* (Société Ornithologique de France et de l'Union Française, Paris, 1957)

Sitwell, Sacheverell, Buchanan, Handasyde and Fisher, James, *Fine Bird Books 1700–1900* (Collins, London, 1953)

Skipwith, Peyton, *The Great Bird Illustrators and Their Art* (Hamlyn, London, 1979)

Der Vogel in Buch und Bild (Naturhistorische Museum, Bern, 1954)

Wood, Casey A., *An Introduction to the Literature of Vertebrate Zoology* (Oxford University Press, London, 1931)

Zimmer, John Todd, *Catalogue of the Edward E. Ayer Ornithological Library* (Field Museum of Natural History, Chicago, 1926)

v Selected Works for Further Reference

Aspden, Thomas, *Historical Sketches of the House of Stanley* (London, 1877)

Barrett, Charles, *The Bird Man. A Sketch of the Life of John Gould* (Whitcombe & Tombs, Melbourne, Australia, 1938)

Blunt, Wilfrid, *The Ark in the Park: The Zoo in the Nineteenth Century* (Hamish Hamilton, London, 1976)

Bourjot Saint-Hilaire, Alexandre, *Histoire Naturelle des Perroquets* (Paris and Strasbourg, 1837)

Catalogue of the Menagerie and Aviary at Knowsley Formed by The Late Earl of Derby (Liverpool, 1851)

Draper, Peter, *The House of Stanley* (T. Hutton, Ormskirk, 1864)

Fraser, Louis, *Catalogue of the Knowsley Collections Belonging to the Right Honourable Edward (Thirteenth) Earl of Derby* (Knowsley, 1850)

Hullmandel, Charles, *The Art of Drawing on Stone* (C. Hullmandel & R. Ackermann, London, 1824)

Hunt, William Holman, *Pre-Raphaelitism and the Pre-Raphaelite Brotherhood* (Macmillan, London, 1905)

Lewis, C.T. Courtney, *The Story of Picture Printing in England During the Nineteenth Century* (Sampson, Low, London, 1928)

List of the Animals in the Gardens of the Zoological Society, with Notices Respecting Them, and a Plan of the Gardens (London, 1829)

Liverpool, The Public Museums, *Handbook and Guide to the British Birds on Exhibition in the Lord Derby Natural History Museum* (1914)

Maas, Jeremy, *Victorian Painters* (Barrie & Jenkins, London, 1970)

Mitchell, Peter Chalmers, *Centenary History of the Zoological Society of London* (London, 1929)

Morris, Beverley Robinson, *British Game Birds and Wild Fowl* (Groombridge, London, 1855)

Morris, Francis Orpen, *A History of British Birds* (Groombridge, London, 1857)

Palmer, A.H., *The Life of Joseph Wolf* (Longmans Green, London, 1895)

Pollard, William, *The Stanleys of Knowsley* (Edward Howell, Liverpool, 1868)

Prospectus of Mr Gould's Works on Ornithology (London, 1873)

Scharf, George, *A Description and Historical Catalogue of the Collections of Pictures at Knowsley Hall* (Bradbury, Agnew & Co., London, 1875)

Sewell, Elizabeth, *The Field of Nonsense* (Chatto & Windus, London, 1952)

Sharpe, R. Bowdler, *An Analytical Index to the Works of the Late John Gould, F.R.S* (Sotheran, London, 1893)

Tooley, R.V., *English Books with Coloured Plates, 1790 to 1860* (Batsford, London, 1954)

Twyman, Michael, *Lithography, 1800–1850* (Oxford University Press, London, 1970)

Vevers, Gwynne, *London's Zoo* (The Bodley Head, London, 1976)

Wakeman, Geoffrey, *Victorian Book Illustration. The Technical Revolution* (David & Charles, Newton Abbot, Devon, 1973)

Waterhouse, F.H., *The Dates of Publication of Some of the Zoological Works of the Late John Gould* (Taylor & Francis, London, 1885)

The Zoological Keepsake, or Zoology and the Garden and Museum of the Zoological Society for the Year 1830 (London, 1830)

PICTURE SOURCES

INDEX